The Expressive Arts Activity Book

of related interest

Dying, Bereavement and the Healing Arts
Edited by Gillie Bolton
Foreword by Baroness Professor Ilora Finlay of Llandaff
ISBN 978 1 84310 516 9

The Chronic Illness Game
Isabelle Streng and A.M. Stradmeijer
ISBN 978 1 84310 376 9 (Board Game)

Reminiscence Theatre
Making Theatre from Memories
Pam Schweitzer
Foreword by Glenda Jackson MP
ISBN 978 1 84310 430 8

Medicine of the Person
Faith, Science and Values in Health Care Provision
Edited by John Cox, Alastair V. Campbell and Bill K. W. M. Fulford
Foreword by Julia Neuberger
ISBN 978 1 84310 397 4

Grief Unseen
Healing Pregnancy Loss through the Arts
Laura Seftel
Foreword by Sherokee Ilse
ISBN 978 1 84310 805 4

Expressive Arts with Elders
A Resource
2nd edition
Edited by Naida Weisberg and Rosilyn Wilder
Forewords by Stanley Cath and George Sigel
ISBN 978 1 85302 819 9

Group Analytic Art Therapy
Gerry McNeilly
Foreword by Malcolm Pines
ISBN 978 1 84310 301 1

The Healing Flow: Artistic Expression in Therapy
Creative Arts and the Process of Healing: An Image/Word Approach Inquiry
Martina Schnetz
Forewords by V. Darroch-Lozowski and David C. Wright
ISBN 978 1 84310 205 2

Inner Journeying Through Art-Journaling
Learning to See and Record your Life as a Work of Art
Marianne Hieb
ISBN 978 1 84310 794 1

Medical Art Therapy with Adults
Edited by Cathy Malchiodi
Foreword by Richard Lippin
ISBN 978 1 85302 679 9 (Paperback)
ISBN 978 1 85302 678 2 (Hardback)

Health, the Individual, and Integrated Medicine
Revisiting an Aesthetic of Health Care
David Aldridge
ISBN 978 1 84310 232 8

Principles and Practice of Expressive Arts Therapy
Toward a Therapeutic Aesthetics
Paolo Knill, Ellen G. Levine and Stephen K. Levine
ISBN 978 1 84310 039 3

An Introduction to Medical Dance/Movement Therapy
Health Care in Motion
Sharon W. Goodill
ISBN 978 1 84310 785 9

The Expressive Arts Activity Book
A Resource for Professionals

Suzanne Darley and Wende Heath

Foreword by Gene D. Cohen MD, PhD

Photographs by Mark Darley

Jessica Kingsley Publishers
London and Philadelphia

First published in 2008
by Jessica Kingsley Publishers
116 Pentonville Road
London N1 9JB, UK
and
400 Market Street, Suite 400
Philadelphia, PA 19106, USA

www.jkp.com

Library of Congress Cataloging in Publication Data
A CIP catalog record for this book is available from the Library of Congress

British Library Cataloguing in Publication Data
A CIP catalogue record for this book is available from the British Library

ISBN 978 1 84310 861 0

Printed and bound in the United States by
Thomson-Shore, 7300 Joy Road, Dexter, MI 48130

Acknowledgments

This collection of activities is only a small sampling of the resourcefulness of the expressive artists who make rounds armed, not with syringes and Band-Aids, but with markers and paper, paint, glue and clay. Thanks to their insightful depths, creative vision and willingness to share, we are able to offer this recipe book for creative inspiration.

Kudos to: Elizabeth Black, Suzanne Jacquot, Karen Palamos, Barbara Skelly and Kristin Spillane. We would also like to thank Lynda Smith for her keen eye and heartfelt editorial expertise, Creativity Explored for sharing their artwork, Brittany Michaelian for the figure drawings, Miranda Darley for her poetry and Mark Darley for his photographic expertise.

In all of the stories, except one, in Chapter 6, "Notes from the Practice," the names have been changed to ensure the privacy of the patient.

Contents

Foreword

For the longest time, views of disease prevention and health promotion in health care were dominated by concepts of medical interventions (e.g. scheduling vaccinations such as the polio vaccine, treating hypertension to lower the risk of stroke, recommending the intake of small dosages of aspirin to reduce of risk of heart attacks, encouraging a regimen of calcium to combat osteoporosis, etc.) along with protective health behaviors (e.g. regular exercise, smoking cessation, moderate drinking, sound nutrition, etc.). Meanwhile, artists and expressive arts therapists alike have long recognized therapeutic, health-promoting and preventive effects that the arts have on the course of health and illness.

But ours is a "show me" society in terms of demanding clear quantitative evidence of positive outcomes from scientific studies before concluding an intervention actually works, no matter how many qualitative reports are published. Moreover, in addition to the evidence, our society demands that we demonstrate a mechanism that explains why something works. Otherwise, the evidence is likely to be dismissed as being questionable or idiosyncratic. The mechanism requirement is particularly the case with behavioral interventions, while with medications there is a double standard, since so many drugs are used where their mechanism of action for the effects they achieve is fundamentally unknown. With the arts, in particular, apparent positive outcomes are often trivialized as "merely reflecting a Hawthorne effect"[1] in the absence of a theory or mechanism to explain what one actually sees.

At last, it is the start of a new day in how the role of the arts is being viewed in enhancing health care. The latest research findings have shown that even individuals with an average age of 80 can show health promotion and disease prevention outcomes when actively involved with the arts. These were the findings of the multi-site national "Creativity and Aging Study" I conducted after a 20-year career of heading programs on aging at the National Institutes on Health (NIH), USA. Support for "The Creativity And Aging Study" was provided by the National Endowment for the Arts and NIH's National Institute of Mental Health, along with four other federal and private sector programs.

In my "Creativity and Aging Study," compared to an age-matched and comparably functioning control group at the start of the study, those in the arts programs after only one year showed better overall health, fewer doctor visits, less medication usage, better mental health scores on standardized tests, and increased activities in their everyday life (Cohen 2006). These were true health promotion and disease prevention effects, along with effects that reflected a reduction in risk factors driving the need for long-term care.

This was also a theory-driven study, where two fundamental underlying mechanisms were at work to explain the positive outcomes: (1) Involvement in the arts increases the participants' sense of mastery—their sense of control. The experience of enhanced sense of control has

1 The idea that a group or individual will change their behavior to meet the expectations of an observer if they are aware they are being observed has become a widely accepted theory known as the Hawthorne effect.

been shown by previous research to be associated, in effect, with an immune system boost—a positive psychoneuroimmunologic response. (2) Those in this study also worked on their art with others, gaining positive group support. Meaningful interpersonal engagement and group support, like sense of control, has also been shown to influence a positive psycho-neuroimmunologic effect.

Moreover, the arts themselves in this study (which included music, visual arts, poetry, writing, etc.) had a positive sustaining effect in keeping the participants engaged. After all, we have known that, since cave people, art has been in the soul of the species. And the latest brain research, pointing to more synchronized use of the right and the left brain in the second half of life, suggests that the arts are especially savored in this process. Baby boomers take notice! This may help explain why folk art is dominated by older artists. With aging, in particular, art is *like chocolate to the brain.*

With this as background, *The Expressive Arts Activity Book: A Resource for Professionals* by Suzanne Darley and Wende Heath could not be more timely, given the health care field's new recognition of proven powerful healing effects from involvement with the arts. This is a state-of-the-art book, filled with creative practical techniques, thoughtful advice and lessons from excellent case examples that all health care practitioners—physicians and allied health care professionals alike—can apply for true therapeutic and health-promoting benefits for their patients and clients. It is tailored for all age groups, varied clinical settings, as well as for both individuals and groups. This book promises to be a terrific vehicle for applying the latest findings from research on health care and the arts for the benefit of both practitioners and their patients. As a final comment on the potential impact of what Darley and Heath describe in their important book, the experience of my wife (sculptor and expressive arts therapist), Wendy Miller,[2] is informative. Her exposure to art—like the techniques described in this book—as a hospitalized child profoundly influenced the course of her lifework. Miller writes:

Memories of making art in a hospital have stayed with me for 45 years—stayed with a kinesthetic clarity I wish my aging mind could bring to more recent events! When I was 11 years old, I spent three months at the Children's Hospital in Boston, Mass., recovering from a complicated leg break from a ski accident. This hospital was located three hours from my hometown in Maine, so my parents stayed with me only partially during the time I was there. In my room was a young girl named Cynthia from China with polio, another girl with curvature of the spine, and a third girl with leukemia. We were all frightened and lonely. Over time, we gradually became more comfortable as our needs for play, friend-ship, care and health were addressed. This process happened in many ways, though it is the activity room and its very special facilitator whose presence I have never forgotten. She created ways for each of us to paint, draw and use clay; most importantly, for each of us to use our imagination in healing ways—to bring our intuition to our fingertips, leaving traces and markings we call art along the way. This was no easy feat, for Cynthia was in an

2 Wendy Miller, PhD, ATR, LPC, REAT, is the co-founder of Create Therapy Institute in Kensington, MD, which houses her private practice and trainings in integrative arts medicine. She is a founding member and elected (past) Executive Co-Chair of the International Expressive Arts Therapy Association (IEATA). Miller has published on medical illness and the arts as complementary medicine, on the use of sandtray therapy with internationally adopted children, on interdisciplinary and experiential approaches to supervision in expressive arts therapy, and on multiculturalism. Miller taught extensively at various universities throughout the USA, where she met and impacted many clinicians in the field, including Wende Heath, who was at one time her student, and has remained a colleague and friend.

iron lung cast, and I was in traction, not to mention the emotional and cultural isolation of living in a hospital away from family and friends, surrounded at such a young age by issues of life and death. I made my very first sculpture there, and it has always been a reminder and a touchstone of my discovery of my life's work as both an artist/sculptor and an expressive arts therapist. My identity in the field was informed by the intimacy of what I learned as a young child, making art bedside.

Gene D. Cohen, MD, PhD, Director of the Center on Aging, Health and Humanities,
Professor of Health Care Sciences and Professor of Psychiatry and Behavioral Sciences
at The George Washington University; author of The Creative Age: Awakening
Human Potential in the Second Half of Life *and*
The Mature Mind: The Positive Power of the Aging Brain

Reference

Cohen, G.D. (2006) "The impact of professionally conducted cultural programs on the physical health, mental health and social functioning of older adults." *The Gerontologist, 46* (6) 726–734.

Introduction

Our purpose in writing this book is to encourage the use of art in hospitals, clinics, schools, hospices, churches and in private practice—in fact any place that people turn to for help. This is a cookbook, a specific how-to volume that attempts to reach anyone who is interested in implementing the arts in healing.

These ideas were born in a hospital, and although the activities and guidelines address physical illness, they beg to be adapted to new settings, populations and applications yet to be discovered. The one important exception is that this work should never be used with a psychotic population, because for them the boundary between the real and imaginary is too frail. If, however, a licensed clinician has reason to believe that this would be beneficial, it is up to their discretion.

Just as there are many situations where art can make a difference, there are scores of individuals who can learn to use art in the service of humanity, whether they are art therapists, expressive arts therapists, artists, doctors, psychologists, teachers, occupational therapists, nurses, clergy or individuals who love art. Art is expression and is just as varied as the individuals who participate in the creative process. There are many ways to "do it," whether one chooses to paint, dance, sing, sculpt, write or combine these different "modes" of expression into a synthesis of one's own interests, talents or abilities. The multimedia approach allows you to meet the challenging needs of the client. If you have a passion for art and people, try it out.

Art and creativity are what distinguish us as human beings, and through art we can connect and help other human beings, no matter what their age, gender, cultural background or diagnosis may be.

We are sure that you are reading this book because you believe that, too. Be sincere. Respect the power of art and greet your patients with presence. These are the qualities that will turn craft into art and help you to help others.

A note on usage

We have used the term patient throughout for consistency. We acknowledge some readers might use the terms client or service user.

Chapter 1

Why Art?

For many patients the hospital experience is frightening and isolating. Separated from the comforts of home, family and friends the patient has to find a way to adjust to a stressful situation while focusing his/her energies on getting well. It is a tall order. How can we help?

We can bring art back to the practice of healing. The expressive arts can be easily adapted for outpatient or hospitalized patients suffering from a physical illness. Imagine the sporty outdoorsman suffering from a broken leg, given the opportunity to career down the blank page with fiery colors…or the terminal cancer patient, given the chance to express grief or joy through delicate watercolors, creamy pastels or bittersweet poetry. In the creative world of art everything is possible.

In the West, medicine has its roots in ancient Greece. At that time the god of medicine, Apollo, was revered as the god of music, poetry and the fine arts. Medicine and art were indivisible. Healing was necessarily an artistic process. Today, however, instead of entering the temple of Asklepios, where we would be cured by tones, intervals and harmonies, we go to the hospital and put ourselves in the hands of doctors and nurses who are specialists in the physical body. We have divided Apollo's realm, and we believe that it is time again to acknowledge the wisdom and efficacy of including the arts in healing.

If we can accept this simple idea, that art and medicine are connected, we can face our patients with the knowledge that the arts are inherently healing, and with that knowledge, as well as a respect for the role the individual plays in his/her own wellbeing, we can assist her in her search for wholeness.

If we can view illness as being out of tune, then health can be viewed as a state of harmony. "Harmony," "art": these two words share the same root, "ar". The poetess and sculptress, MC Richards, traced the etymology of the English word "art" and found that it meant "to fit together, to join," and that the word "harmony" has the Greek root "harmos," which means "the shoulder where two bones fit together." Thus art and harmony are about connection, about fitting together in a way that holds. We can help our patients toward a harmonious state by helping them to understand their interconnection with the world through the art experience, whether it be through music, painting, drama, movement or the visual arts.

Carl Gustav Jung, the groundbreaking psychologist and philosopher of the last century, also understood that the art experience was crucial to self-knowledge and believed that self-knowledge brought healing. In *Memories, Dreams and Reflections* (Jung 1973) he chronicled his life as an attempt to understand himself through imagery and the artistic process. Although he believed in the activating power of art and its ability to transform and enlighten, it was not always clear to him that the path he followed was art, but he was clear that the artistic process itself brought clarity to his mission. He wrote:

While I was writing down these fantasies, I once asked myself, "What am I really doing? Certainly this has nothing to do with science. But then what is it?" Whereupon a voice within me said, "It is art."

...I said very emphatically to this voice that my fantasies had nothing to do with art, and I felt a great inner resistance. No voice came through, however, and I kept on writing. Then came the next assault, and again the same assertion; "That is art." This time I caught her and said, "No it is not art! On the contrary it is nature," and prepared myself for an argument. [No argument occurred]

(Jung 1989, pp.185–186)

We believe that there was no argument, because art and nature walk hand in hand. Like nature herself, we are creators: we are hard-wired to be artists, whether it is to make tools, sing a song or pro-create. If medicine concerns itself with natural forces, it should include art as a way to treat disease. As practitioners of the expressive arts, whether we are nurses, therapists, doctors, social workers, hospice workers or artists, we have the opportunity to bring more art to the craft of medicine and help countless individuals forge a path toward wholeness, by gently engaging their creative selves.

Why art heals

In order to understand the efficacy of the expressive arts, it is not necessary to read up on studies, devour Jung, or even review the theoretical arguments that underpin the philosophy. One must only agree that knowledge and understanding of one's self and one's illness can move one toward wholeness.

However, we do know that an understanding of how art can be healing is supportive information for the expressive arts practitioner. There is a large body of literature available for those interested, but the main ideas include how to be with the patient (which will be discussed at length in the following chapters), and the transformative role of self-knowledge gained by working artistically.

Since the ancient Greeks, who gave us Apollo—the artist and healer, also admonished us to "Know thyself!" We will start with the role of self-knowledge in the practice of the expressive arts.

Self-knowledge: the dance between inner and outer

The expressive arts are primarily an *educational* process that is therapeutic because it moves the participant toward health. Well, healthy, whole…these adjectives all relate to a state of completeness. If we lack certain knowledge then we are not complete in our understanding. If our goal is an understanding of ourselves in the world, i.e. ourselves in relationship with our illness, then seeing information that brings us new insight can move us toward wholeness. When we learn something new, we gain insight and have a greater capacity for understanding. We begin to grow toward the fullness of who we are.

Knowledge and education are, of course, deeply related. The goal of education is to bring us knowledge. To understand how education works, we can study the meaning of its Latin root, "educare." It means "to draw forth." True education, then, is not something that is poured

into students but is, instead, an internal change. It is measured by what students produce, what comes forth. Their papers, exams, etc., are only concrete manifestations of the real learning, the knowledge that develops within. New material is presented, the student digests it, adds his own thoughts and then brings his new understanding into the world through his assignments. Thus, education is the interweaving between inner and outer realms.

In art inner images meet paint and paper and inner music becomes the sound of a symphony orchestra. There is a continual dance between inner imagining and outer form, between creation and expression.

Art's power of connection cannot be underestimated. The potter, painter, sculptor, singer, dancer, musician, poet and patient are connected to the material world through their specific medium. They are also connected to their inner world through their thoughts, dreams and emotions. Colors on a palette speak to feelings of the soul. A movement in the air answers an inner gesture of intention, thought and feeling. A melody responds harmoniously to a moment in time. Art is a response which moves the participant from one place to another, and which connects feelings, thoughts, materials and insights. Art leaps into being when these different worlds merge. It connects the artist to his/her audience and community and in the case of the expressive arts it connects the patient with the expressive arts practitioner, because together they have witnessed the creation and presence of the artwork.

Art has another very special function in regard to the internal world: it can also engage the *unconscious*. Art is therefore deep education. It allows one to express the unknown from the unconscious depths of one's being and allow the unknown to become knowledge in the light of consciousness.

Art's transcendent and transformative capacity
Connecting with the unconscious through symbols

Jung saw the polarity of inner and outer as wholly internal, within our own psyches. His division lies deeper than the one we discussed above. In Jung's vision a type of permeable barrier lies between our conscious and unconscious minds that can be transcended by *images*. Images give the unconscious a voice.

Given our perception of inner and outer, coupled with Jung's vision of the conscious and unconscious, art can be seen as uniting three different worlds at once: the unconscious, the conscious and the world of concrete, material form outside the body. Art is able to unite these three realms because it expresses itself through image, and image is a language that can be understood in all three realms. By making the unknown conscious, through the creation of images, self-knowledge and the integration of inner and outer can occur. It is a transformative experience that taps all the levels of one's being simultaneously.

It is very exciting to think about art's ability to breach the division between the conscious and the unconscious. We must not forget, though, that the flow of information is a two-way street. It can percolate up from the depths or seep in from the outer world. Patients have to deal not only with unconscious fears and unanswerable questions, but they also have to come to terms with physical pain, what the doctors are telling them and how they are feeling. Every day, with every blood test, every visit from the resident, new information needs to be integrated into the patient's view of his wellbeing. Through artistic expression, the patient is

given the opportunity to understand more fully who he/she is at that particular moment in that particular set of confusing circumstances.

Art integrates in other ways, too. In addition to its ability to cross boundaries and integrate knowledge, art has another special ability derived from its symbolic function; it can hold paradoxes. Images can hold more information than we can grasp all at once with our rational mind. Symbols can be viewed as activated meditation. They arise from deep within from a place that is essentially unconscious and give the ineffable form. This is a capacity that can help patients deal with the mystery that underlies suffering, illness and aging. Symbols carry meaning and this knowledge and understanding can dispel the mystery and lead to relief, acceptance and sometimes gracious surrender. The power of symbols should not be underestimated.

Differentiating signs and symbols

In order to understand this special capacity more fully it is necessary to take a closer look at symbols and at signs because they can both appear in patients' artwork. They function in different ways, and understanding the difference can help the expressive arts practitioner understand the depth of the experience for the patient. In short, when symbols appear, the patient may need several sessions or more time simply to reflect after the art experience.

Signs should not be underestimated either, but the patient probably already holds the key to decipher his or her own symbolic language.

According to Jung (1973), there are distinct differences between signs and symbols. Signs are simply an abbreviation for something that is known. They point to a concrete reality whereas symbols express a dynamic reality that by its very nature is constantly changing.

Signs are the same as that for which they stand. For example, a road sign with a picture of a bridge means that there is a bridge ahead. There is no covert meaning. The sign is explicit and easily identifiable. It is easy to create signs. If you are a baker, hang up a shingle with a loaf of bread painted on it; potential customers will know that you sell bread. Signs are precursors to language; they communicate what is concrete.

For example, there is a children's monthly magazine that always has a two-page story for the center spread. The stories are written in bold letters, but the nouns are replaced by pictures. Instead of reading the letters s p a r r o w, the children follow along and call the signs by their names. One of our sons learned to read this way; every time he saw a picture of a sparrow, he said, "sparrow." The signs made language less abstract and more immediately accessible. For a patient, a blue giraffe might be simply that—a blue giraffe, or it might represent the comfort of childhood, because the patient loved a stuffed, blue giraffe he had as a child.

Symbols, unlike signs, are not as easily created. According to Jacobi (1959, p.80) "It is therefore quite impossible to create a living symbol, i.e. one that is pregnant with meaning, from known associations." A symbol, then, is something much more complex than a sign. As it cannot be created out of what is known, it must be composed of material that is unknown, that is *unconscious*.

In *Complex, Archetype, Symbol* (1959) Jacobi states that symbols are "never entirely abstract, but always in some way incarnated" (p.76). This points to the pre-existence of symbols. In the unconscious, symbols are constantly being generated. They are always manifesting as symptom, symbol or complex. The concept of incarnation carries with it not only the sense of

being born, but also the sense of pre-existence—something without form taking on a discernible presence.

Symbols as carriers of unresolved paradoxes

Symbols, unlike signs, have the capacity to hold several meanings at once and therefore can provide comfort and assurance to the ill. For example, in an image, life and death are not mutually exclusive; they coexist without threat, because they are held by the medium of the artwork itself, rather than by the consciousness of the patient. Through art, the patient can let go of such struggles and still be conscious of them. In concrete form, in pencil and paper the deepest paradoxes can exist without turmoil *outside the patient*.

A good example of this is a familiar icon, the yin/yang symbol. This symbol holds a polarity as a unified wholeness. Just by looking at it one understands that the darkness cannot exist without the lightness, and that the little dab of dark in the light and the little dab of light in the dark attest to the fact that they are inherently connected. The line that wavers between the two represents a fluid dance between the light and the dark… We apprehend this image as a whole all at once, but when we try to describe it in language, we have to describe discrete opposites: black and white, up and down, inside and outside, right and left. We cannot talk about them together in any form other than opposites!

Yet, these parts that appear to be mutually exclusive even though are integrated into a dynamic relationship that defies the construct of language, images can connect and order seemingly disparate entities.

Paradoxes in patients

An image might arise for the patient that represents mortality and healing at the same time. In this instance the patient is grappling with one of the great, eternal paradoxes of existence. One is dying while one is living. One is living while one is dying. How can this be?

Through art the patient can let go of troubling, unanswerable questions, and suffering is relieved by removing that burden from the patient. This function of art is key to the power of the expressive arts and especially important for patients who face the inexplicable every day.

We have seen that the symbol can express the wordless. The symbol, the image, the melody…all of these artistic utterances have the ability to express something that cannot be apprehended with language or rational thought. Paradoxes are among the least explainable situations we face—and patients, as we shall see, are faced with paradoxes the moment they become ill.

One of the first paradoxes one encounters in dealing with physical illness may not be as clear cut as a question of life and death. The paradoxes may be more subtle…and may revolve around the nature of disease itself. Where does the individual end and the disease begin? Are they the same thing? Are they separate? Am I diabetes? I am certainly a diabetes patient. Am I basically healthy, but sick at the same time? How could I be both…? Every patient will struggle with this to some degree. This is a specific juncture where art can make a difference in the patient's quality of life. Sometimes we may see a hospitalized patient only once, if they are in for a short stay. Art can help them immediately. The symbol can hold a paradox that the rational mind cannot yet apprehend.

How can I be me, the me I was yesterday, but now be someone different because of my diagnosis? In trying to understand their illness patients may begin to ask questions directly of the art process. How can I describe my disease process? How can I describe my disease process as different from yours? How do I hold on to a picture of health? Art can help with all of these types of questions, because of its integrating power.

Unfortunately, a patient can be viewed as a disease, rather than as an individual—the prostate cancer case, or the hepatitis case or the emphysema case, etc. A pattern of disease is dynamic. When I say "bubonic plague," that name carries with it a whole host of different meanings: the disease, the way it manifests, its infectious nature, its effect on the history of humankind, and emotional responses such as "it's frightening," "it's horrific," etc. Bubonic plague is a whole complex of meaning. Diseases are like that. They do seem to have a life of their own. Appendicitis presents itself with abdominal pain on the right side, a broken ankle presents itself with pain, swelling and discoloration, etc. We know we should not confuse the disease with the patient, but how do patients relate to these patterns? Art gives them a way to make sense of this flurry of information.

Symbols in action

Another example of a symbol may be found in the patient with Alzheimer's who kept painting a goldfish in all of her work. She could not finish a piece without a goldfish swimming toward the center of the paper. After weeks of working together, the truth behind that little, seemingly innocuous, symbol started to emerge. The goldfish was her desire to swim free and be independent and it was also her desire to be cared for, fed, kept safe in a world that would continue to make sense to her. Her goldfish represented the paradox of her radically changing existence. Yet the saga of the goldfish did not end there. She journaled and wrote poetry to the little fish and began to consider what goldfish meant to most people. Rather than the humorous, free spirited little fish she had been drawing, she began to see a captive creature, scrutinized at length in a glass bowl and hunted by patient housecats. For her, this realization was again extraordinary. In addition to the paradox of freedom and captivity she came to another, significant realization. That little goldfish also carried her feelings about death. The first time she ever experienced death was when she was a little girl and tried to play with her pet goldfish in her bedroom. Not only was it the first death she had experienced, she was also responsible. This symbol opened a doorway for her to explore her own fears, desires and mortality, because she realized that she was this goldfish—both alive and dead, captive and independent. Touching such an awareness brings not only clarity, but also relief and understanding.

The symbol of the goldfish emerged out of a place of creative effort and evoked a new understanding of life for the patient. Unknown to her, she was working with an archetypal symbol that was also cloaked with personal experience, both conscious and unconscious.

If one were to research the symbol of the fish, it would be revealed as an ancient symbol of reincarnation, and although the patient might not have directly accessed that specific meaning in her discussion of the fish, she did come to understand it as a symbol that held the paradox of life and death in one image.

Thus the images that arise are present in two places at the same time: the conscious and the unconscious. They leap over the chasm between what is known and unknown and thereby

connect the patient to her unconscious by cloaking the unknown and the unexplainable with a mantle of imagery. Imagery that can be grasped by our senses gives unconscious material concrete, understandable form.

The concept of a blue square can easily be painted. What was once inner and hidden can be translated into the materials of the outer world—paper and paint. Unconscious material can be given a physical presence! The little goldfish begins as an idea, becomes an image and ultimately a living reality for its creator.

This is integration. It is important to note that the artwork itself is not the integrating factor; it is the act of symbolization, the emergence of image into consciousness, that is the integrating process. The images that arise do not *need to be analyzed, or even discussed in order to be effective*. This is an essential point that will be taken up in the next chapter when we discuss how to work with patients.

Considering symbol invocation through expressive arts

In the case of a terminal diagnosis or a severe, acute illness with a healing crisis, a sense of mortality can suddenly flare up with a vengeance. Our society generally shies away from discussing this basic fact of life: we are mortal. Art, as I have mentioned above, is a safe haven to express unexplored fears or the imponderable realities of existence itself. Symbols allow us to explore unconsidered territory without fear or misconception. Art is never "wrong"—it simply "is." The symbol appears, it carries meaning and its meaning may continue to unfold for the patient over many sessions. Just like the little goldfish.

It is difficult to compress the complexity of a symbol or metaphor into language, because of the nature of language itself. Language wants to fix the ambiguity of a symbol or metaphor into a static form, but ambiguity wavers; it is not fixed. Language is precise. By its very nature it divides in order to identify. Remember the yin/yang symbol? We can only describe it by describing the two opposite poles of light and dark.

In expressive arts work, poetry is the most effective use of language, because, at heart, poetry is a language of image and has the capacity to work like a visual image, movement or sound for the patient. There are many ideas for integrating poetry in the following chapters that suggest ways to play with language's ability to create images, signs and symbols.

As the relationship with the patient develops over time, and the patient feels more comfortable in the art-making process, the sessions may become more and more conducive for symbols to arise and with them the extraordinary opportunity for transformation increases—just like the saga of the little goldfish.

Although not all artwork can be described as truly symbolic, in the strictest Jungian sense, all artwork does have a symbolic quality, because it is pregnant with connection. Pieces relate deeply and dynamically to the artist who gave birth to them. Working in the expressive arts field, we tend to believe that much of what comes forth in a session with a patient is symbolic, even though it may look like a "blob" or "Aunt Ellen's house by the sea." Each image has the capacity to carry with it an entire complex of meaning. One should never be dismissive of an image or assume that one image is more important than another, that one is a sign and another is a symbol. The patient will guide you. Take your cue from them. We do not know; only the patient has that knowledge and the ability to unlock the secrets of their own creative process.

The role of the artwork in expressive arts

Previously we have placed more emphasis on the process rather than the final product, because it is the process of art-making itself that is integrating. The expressive arts are about making, doing, creating. Unfortunately, some patients may at first be reluctant to touch the art materials because they equate art with professional artists. They can feel inadequate. This fear diminishes when they realize that it is the process that is emphasized, not the final product. Therefore, it is doubly important that the final product in expressive arts does not hold the same weight as the process.

It is the journey that must be emphasized, not the arrival. One starts at point A and ends up at point B. The path inbetween is one of self-discovery. The final product, the artwork, lets the patient know that he or she has arrived. It reflects the momentum of the journey while welcoming the patient to a new place. The art-making process continues to affect the artist long after the completion of the piece. Harmony continues to echo. Knowledge continues to inform.

However, it must be stressed that the art piece means something completely different for each patient. It is the role of the expressive arts practitioner to witness the act of creation and accept the piece exactly the way the *patient* presents it. It is the patient's time, the patient's art piece, the patient's life that is on the table. The job of the expressive arts practitioner is just to be present. This will be discussed further in the next chapter. It is easy to imagine connection with a visual piece, but less easy to comprehend when it relates to a song or gesture—art forms that are ephemeral and temporal in nature. They exist only once, whereas a sculpture or a drawing may last for generations. Yet each one is an artistic utterance on the conscious, physical plane of reality. We see it, taste it, touch it, feel it, hear it, and because both the creator and the witness have experienced it, it becomes a meeting point for human interaction. For patients isolated from home, their friends, family, partners, their routines and comforts, the value of simple human contact—of connection—cannot be underestimated.

Facing major hurdles: a patient's perspective

Patients are vulnerable. They find themselves in a place that is essentially different from where they were before. Their sense of wholeness and completeness is shattered. Recovery is finding equilibrium again—recovering that state of completeness and harmony that was health. An illness usually brings questions, new information and insights, all of which need to be integrated into the patient's worldview, so that rather than feeling shattered, the patient can feel complete. We think it is important to mention here that completeness and recovery, or wellbeing, might not necessarily mean cured. One can be whole and complete even at the time of death. Wholeness is greater than the physical body alone.

Our task is to meet patients right where they are, in their personal process. Many face mortality while in the hospital, and tough, existential questions often arise. For many, illness is an adversary. One does not usually leap from severe illness to perfect health overnight, and rather than being viewed as a gradual shift toward wellbeing, recovery is often characterized as a battle. "I'm fighting something off," "I'm trying to get over something," etc. Patients often take an all-or-nothing stance. There is me and then there is the illness. There is either health or illness. But, is that really true? We know that everything is constantly changing, health fluctu-

ates, it is not stable, and surely getting better is a process. Patients can be very impatient, especially when they are in pain and feel threatened. After all, who wants to be sick?

This attitude toward health can be a major hurdle for the patient. They might not want to be in relationship with their illness. If illness is viewed as "other," as something that happens *to* one, why would one want to get to know it better? Why would one want to own it?—the pain is enough. Why integrate? Is it not better to try to separate ourselves from it?

That desire to separate stems from our analytical approach to life. All around us knowledge is presented as being specialized, and as we have seen, even language, our favorite form of communication, divides. We are good at separating and naming. Doctors diagnose, it is me against the disease, etc... But how do we reach real understanding? What about our powers of integration? Do we not want to become whole?

On one level, to regain a sense of wellbeing, patients must recognize that for now, illness is part of the complete whole; physical illness *is* them—a part of them they do not usually understand because it is different from what came before and different from what they expect of themselves.

As practitioners, we must remember that no matter how difficult the situation, art does not hurt. It always assists in a supportive and safe way. The colorful materials bring joy, the human contact brings comfort, suffering is relieved, and most important, the patient controls the process and will go only as far as he or she is comfortable. Jung actually felt that the self was a good editor, allowing only enough material to arise that could be integrated without overloading the conscious self.

In the words of Wendy Richmond (1997), art allows the patient "to grapple with the unexplainable." In the authors' experience, unexplainable questions lurk at the core of every patient's relationship with disease. The ill often search for solid answers in their fluctuating worlds. They constantly ask themselves: Why me? Why do I have cancer? Why did I have a car crash? Why do I have to suffer? What have I done? They search for cause and responsibility; after all, we live in a world of cause and effect, do we not? We also live in a culture that is quick to assign blame in the face of misfortune. Yet illness does not necessarily fit into the cause/effect/blame model. So how do we relate to something that is outside our normal experience?

It is a rare person who can live gracefully with the unknown, especially when it affects their life so deeply. Luckily, greater understanding—such as that that can come from working through the expressive arts—often makes it unnecessary to search further for an answer. Patients can find relief through the clarity of self-knowledge. They can let go of emotional suffering when those burning questions disappear from their list of worries. Pain levels often reduce, too. Art helps make sense out of something that is not logical and sometimes fills the void with unexpected answers.

The murky world of unexpressed emotions and feelings that can arise as a consequence of illness is given safe expression through art. In art, that hidden world is given finite and concrete form in the art piece. Inner life, outer life, emotions, symptoms—they all come together on the page as one. What before seemed unbearable can be reborn through art into something "bearable." Art-making gives a story to the illness without having to objectify it through language or experience it through pain. For the patient this is the chance to make sense out of the unexplainable in a non-invasive, non-threatening way.

At this point it is also important to take a moment and reflect on the word "patient." It connotes passivity. Yes, the patient needs rest. Yes, healing can take time, but it does not mean that the patient should not be engaged consciously and actively in the healing process. As soon as the patient begins to make art, he or she becomes a consciously active participant in the healing process, whether or not she is ambulatory or has the strength to participate physically. No one can be passive and "do art." Art demands effort from the individual. If the physical effort is too taxing, at the minimum *presence* is necessary.

The expressive arts—movement, poetry, visual art, music—can be brought to those hospitalized in a form that meets their needs. They have usually just left a situation where their ability to care for themselves deteriorated very quickly. So, at the outset, the patient is catapulted into another way of being—inactive, incapable, dependent. Art-making immediately gives them the opportunity to be engaged and active. This opportunity to act is rare for those in the hospital, where things are "done to you": an early morning temperature, a new IV line, medications, surgeries, procedures, poking and prodding. Many cultures claim that the patient does the healing, and that the doctors assist the patient in the healing process. One should not forget that it is *one's* immune system, *one's* intention, *one's* commitment to a healthier lifestyle, among other even less obvious factors that can promote *one's own* wellbeing.

The expressive arts process is a gentle way to reach out to those in need. Once engaged, the expressive arts can lead the patient to a greater understanding of herself and her relationship with illness.

Pablo Picasso supposedly said, "Someday we should be able to paint pictures that are capable of curing a person's toothache." In the hospital setting the expressive arts give us the opportunity to aspire toward that very ideal. We have not yet seen a miraculous recovery through watercolors; yet extraordinary things can and do happen. We regularly see significant changes, such as pain reduction, relaxation and a sense of delight in meaningful human contact. Most striking to us, however, are the intellectual, emotional, and spiritual changes that are less easy to quantify, but which are equally, if not infinitely more, significant because they are often the catalysts for change that aid the patient in his/her search for health. I believe that art is at the core of our nature as human beings, and that by reconnecting with our inner creator, our inner artist, we can recover our sense of wellbeing.

You can begin right now. The following chapters include guidelines for a successful practice, special tips for working with patients, a few case studies to give you a feeling for the work and many, many ideas to experiment with or take at face value. This volume is intended to be a "cookbook" that will whet your appetite and get your own creative juices flowing. Have fun and remember that the patient and the art work will guide you. Your main job is to be present and savor every moment in the creative space.

Chapter 2

Who Should Use This Book?

As we mentioned in the Introduction, our goal is to make the expressive arts experience available to as many patients and types of practitioners as possible. Expressive arts therapists, expressive arts educators, art therapists, marriage and family counselors, psychologists and psychiatrists, all have professional backgrounds that would allow them to dive right in with knowledge and expertise in the field. Each one of you has a different arena of expertise; sometimes you overlap in your approaches and sometimes you do not. No matter what your professional approach is, you have the knowledge that will allow you to adapt any of these exercises to your patients.

However, there are many other individuals who can use the material in this book too. Rather than discourage anyone from trying these activities, it is better to state the obvious: these activities, although they may seem like simple, innocuous, art projects are potentially profound. Attention must be paid to the type of patient you are working with and also whether the expressive arts activities are intended primarily as a *therapeutic* activity. These activities, because they are intended to awaken self-knowledge are inherently *educational* and most can be used in group settings or even in individual sessions where the stated goal is something other than *therapy*. That means they can easily be adapted by artists in residence, teachers, chaplains, etc. and can be effectively used in educational settings, workshops or offices.

The intention with which you bring the work to your patients sets the tone, because intention defines both the approach and the expected outcome. The patient has different expectations when he/she meets a doctor, or a teacher, or an artist. The approach, which must always be nurturing, regardless of your professional status, colors the entire interaction with patients. If you are not a therapist, or do not have supervision by a professional, do not present these activities as therapeutic. Bring them as art, education, entertainment, play, a point of connection… Consider yourself an educator or artist, or be someone who just loves to share the art process. One "label" is not better than another; it is just different.

Undoubtedly this will raise eyebrows in the therapeutic world. So, let us give you an example of how this might look in practice. A therapist might take the exercise "Day and night mandala" (p.125), for example, with the intention of opening up a conversation about what is dark and what is light in one's life. This can be a very potent exercise and together the patient and therapist can forge a way to approach and understand the material that arises. An expressive art therapist works predominantly artistically rather than verbally. He or she might have the patient work multi-modally and move the darkness, or describe it in poetry or sound rather than use the artwork as a springboard for dialogue. Through expression, then, art itself

is the activating as well as the therapeutic force. Dialogue with the patient might or might not follow, or the material discovered in the art-making may be taken up in a following session.

An expressive arts educator might do the exact same exercise, but there is a subtle and powerful difference: the educator wears a teacher's hat and the impetus for change is clearly in the hands of the patient, because the teacher never accepted the role of "healer," but instead remained firmly a witness to the patient's process.

Now, a teacher in a classroom might do something completely different with this. She or he might explore the concrete reality of darkness and the concrete reality of light—this assignment could become an exercise in balance and polarities in nature. In a follow-up written assignment students might explore these new insights.

In the framework of social activism, a teacher might use this exercise to initiate a discussion on diversity, race relations and civil rights. What is black? White? What is the shadow—xenophobia? And so on. It is your creativity that will make this book work for you. All of the exercises can easily be adapted to different situations, but a few in the theme-based activities section might relate specifically to family dynamics, or pain, and as such would be less malleable. There are over 100 activities in the book and no matter what your persuasion, there are activities appropriate for you to employ in your work.

Considerations for different practitioners

Expressive art and art therapy practitioners, interns and students

Much of this information may seem very basic to you, but we feel that you can never have too many ideas tucked up your sleeve. The best work is always tailored to the individual patient and the more you know, the more you can offer. Feel free to adapt and alter any exercise as you see fit. You might choose to skip right to "Activities" (p.55).

Medical personnel, child life specialists and therapists

We have tried to present simple projects that anyone with an interest in art can do. It is important to understand what and why you are doing art (see "Why Art," p.15) and to take to heart the information in the secrets of success and failures sections (see p.31).

Artists and educators who want to work with patients

These ideas can only add to your repertoire. Already you have a list of activities and materials that speak to you. Some of our activities, especially the icebreakers, might help you to reach a segment of the population that feels they "can't do art." Keep exploring new avenues to engage the "non-artists."

Novices

You may feel completely unprepared, but fascinated. Take a deep breath and follow your passion. You might ask yourself all of the following questions, or none at all. We are sure that we missed quite a few, but in order to get started we hope that this will suffice.

"I DON'T HAVE THE TALENT"

It is not necessary that you are a gifted artist, art therapist or expressive arts therapist. It is important that you understand what you are doing and limit yourself to the materials, projects and population you know. For instance, most people have made cards in their lifetime. Put together a box of card-making materials (see Cards, p.59) and concentrate on that until you have learned more projects.

"I DON'T HAVE THE PERMISSION OF MY FACILITY"

It is important that you have permission. If you are a nurse, your head nurse should know exactly what you are doing, why, and how much time it will take from your regular duties. Medical people are often very nervous around art materials ("they are too messy," "not important to the patient's healing," "foreign to their experience," etc). The best way to counter this kind of thinking is to include them in a project. Five minutes of glitter, glue and laughter gets everyone on board.

"I DON'T HAVE THE TIME"

We are all rushing around with too much to do and not enough time. Take the time. A few minutes of paint and pictures will relax you and the patient, making your work easier and the patient's day brighter. We have included activities that are very short (See Icebreakers, p.57) as well as longer activities (see Media-based, p.86 and Theme-based Activities, p.101).

The Turf War

There is a debate in the field that arises—sometimes as real, outspoken conflict—between art therapists, expressive arts therapists and child life specialists. At this point, the argument relates to work in the hospital and hopefully it will end here. We are convinced that there is more than enough room for all of us to practise and there are certainly more patients than all of us working together can ever serve. Needless to say, the hospital is only one venue. What about taking the work into social activism, what about helping students gain skills through group work to be successful learning communities…? Take off your blinders and look around. The world needs healing and you can help.

If the core of the practice is to respect the patients, we must begin by respecting ourselves and our fellow colleagues and the strengths they bring. As long as we have been in this field, we have heard this silly debate. So we would like to dispel some of the prejudiced "myths" we have heard over the years by bringing them right out into the open: "Only trained art therapists can do this work because of their unique set of skills from having studied both psychology and art."

It is true that art therapists and now expressive arts therapists and educators have a great deal of training. In most cases, they attend graduate school for two to two and a half years and have completed up to 1000 hours of supervised work. Art therapists learn how to use art processes for assessment and diagnosis, but that is not all they learn. They learn about appropriate art techniques for various ages and diagnoses, they learn about art materials, and they learn about psychology. This makes them prepared for a variety of settings.

Art therapists seldom use formal assessment and diagnostic tools such as the *Diagnostic Manual of Assessment and Statistical Manual of Mental Disorders* (*DSM IV*) (American Psychiatric Association 1980) in the hospital, unless they are working with a mentally ill population. Good art therapists and expressive arts therapists and any other therapists look at art work with curiosity. They have learned to ask open-ended questions to find out what and *if* there is anything to be said about a picture, sculpture or any other artistic expression that would be beneficial to the person or the art process. Sometimes "a cigar is just a cigar" and often nothing need be said, and certainly nothing needs to be analyzed!

More often than not, even with a capacity to name a diagnosis, the good art therapist will simply be present, silent, helpful and supportive of the patient's process. Art making does the magic; therapists are facilitators who enable the art and the artist to do the healing work. "We only hire artists. We never hire art therapists because they do assessment and diagnosis and we never do that."

This is a silly statement. Good practitioners do assessment and diagnosis (maybe not with the DSM IV, but diagnosis nevertheless) from the first second we enter a room. As good therapists or artists or nurses, we observe everything we can about the situation. We ask:

1. How is the patient positioned in bed or in the room? Is she sitting up, in the fetal position, well-groomed, very sick-looking?

2. What does the room look like? Are the shades drawn, are there lots of flowers and cards, etc.

3. Who is in the room with the patient? Are there parents, friends or does the patient never have visitors?

If we are allowed to read the patient's charts, we have additional information that can help us in our approach, and if we cannot, we can always ask the nurses for insight.

For groups we might ask ourselves:

1. How many patients are there, what age, ability, level of attention and what is their state of health?

2. What is the comfort level and interest of the other staff in the room?

3. Do they attend the group regularly? Are the patients difficult to engage?

We learn to make an assessment quickly about the emotional and physical state of the individual or the group (sad, happy, depressed, very sick, low energy, eager, etc.) and from that assessment we determine how to approach the patient or group: are we going to do visual art, song, poetry or a combination of modalities, and how will we adapt our plans and techniques to the present situation? The more experienced at assessment and the more creative one is, the better prepared one is, and that makes it more likely that one will have a good outcome from the session. In other words, the more preparation and understanding one has, the easier it will be to meet the patient's needs. Remember though, everyone has to start somewhere, and beginners bring fresh minds and energy that can only add to the field.

"WE PREFER HIRING ARTISTS TO DO THIS WORK BECAUSE THEY ARE MORE CREATIVE, FREE, ARTISTIC, ETC."

Creativity and adaptability are important in this work. Artists do not have ownership of creativity. Someone who is a fabulous painter may be unable to work well with patients because of certain personality traits. Psychologists and nurses who love art and know some art processes are sometimes better than artists—note we said, "*sometimes.*"

Our belief is that cream rises to the top. Training, especially on the job training, helps but good practitioners, no matter what their field, who can be present to what is going on at that particular moment, with that particular patient, can do the work. Turf wars are not productive in bringing this work to the world, but that does not mean that we should not be professional in our approach. An amateur is someone who does their art for love and one can be an amateur and still be professional in their approach. The expressive arts is serious work that requires respect for one's colleagues, the patients, the tools, the process and the outcome.

Following are some broad statements made over the last ten years by expressive arts practitioners while training at the hospital:

Art therapists sometimes need to relax and just go with the flow.

Artists sometimes need to know more about what to expect developmentally from children and something about defense mechanisms and other basic information about how people react under stress.

Teachers sometimes need to stop teaching and helping and allow patients to explore for themselves.

Doctors and nurses sometimes need to deal with their need to fix people and just listen and let the patients be where they are (especially when there are tears).

We *all* need to work on all of the above. Each one of us is a healer, an artist and a teacher, otherwise we would not be drawn to this work. We each need to learn as much as we can about art materials that work for us, learn how to deal with grief and disappointment and learn how to take good care of ourselves so that we can continue to do this work.

Chapter 3

How to Be with Patients:
Presence, Presence, Presence

Secrets of success: presence

This is the most important section in the whole book. The secret to your success is your *presence*. This means that while you are with a patient you are 100 percent there in mind and spirit. As much as possible (and for nurses this can be more difficult), be totally with the patient. If you can really focus totally (and do not have to listen for other patients and alarm bells) you can behave as if you have all the time in the world. Or you can say I have ten minutes that I can spend *just with you*. Undivided, loving attention is the best gift you can give anyone.

You are not trying to do anything to anyone. You are not trying to fix them, teach them (although you might), analyze their art or make anything in particular. Your presence creates a "holding environment" that enables patients to feel safe to explore their inner world. You are trying to accompany them in an exploration of materials and projects in the hope that you can engage them with the art and with your compassionate personality. You are trying to have as intimate a human exchange as is comfortable and appropriate for you and the patient, so that when you go they feel seen and loved and accompanied on their journey.

Secrets of failure: lack of presence

Patients lack power. They are very sensitive to someone who does not have their best interests at heart. If you are focused totally on your success, your project, the art, or analysis; the patient will feel it and reject you and your art. If you are present and have a warm interaction with the patient, even if you never make any art, you cannot fail.

Help!
"The patient doesn't want to do art!"

Patients have procedures done to them all day long. Sometimes you are the only person they can say no to. Consider this refusal empowering to them and do not take it personally. Sometimes talking to a patient, reminiscing, making up stories is the art. Sometimes a patient is afraid of art and needs to be carefully and lovingly encouraged. Wonderful materials that they have never seen sometimes make patients curious to try them. We have included a number of projects that are designed specifically to encourage the reluctant artist who says, "I can't do art." Producing no art is not a failure as long as you are fully present with the patient.

"I don't know how to do a particular technique"

It is important to know how to use the art materials you present. Practise at home or take some classes. Make some samples to help patients visualize their own art. If you really do not know how to use watercolors either do not offer them, or present them as a mutual exploration: "Let's see if we work together, we can figure out how to use these paints."

"The three-year-old is throwing paint; the teenage boy is refusing to talk"

Know the population you are working with. Sometimes we learn by cleaning up thrown paint that a three-year-old should not be left with—colorful, gloopy paint. Three-year-olds just love to throw or drip or mix paint with their hands, if given the opportunity.

A teen-aged boy is devoted to being cool and will not answer direct questions if he can avoid it. Learn about boys and how to engage them by reading books, watching people who are good with them, or experimenting with different techniques and expecting occasional failures. With a little knowledge you can bring to them activities they will respond to and that are appropriate for their age and developmental level.

"The family looks suspicious, uninterested, or over-involved"

Remember when you enter a room, everyone in the room is your patient. By presenting interesting projects or material you can encourage everyone to get involved. This is often a great relief for visitors, who do not know what to do with themselves, and the patient, who is often fatigued entertaining visitors. To the over-involved mother who tells her child how to do everything or what not to do, it is important to get the mother focused on her own work or set her up as the child's helper or assistant.

What not to do

Do not name it

Do not label a piece of work, saying, "Oh, that is a pretty dog," because the person might have been drawing a horse. A simple comment like that could kill the work and shame the artist. Ask only open-ended questions such as, "Would you like to tell me about your picture?" "Is there a story to your picture?" "Is there a name for your picture?" In Antoine St Exupery's book *The Little Prince* (St Exupery 2000) the author begins the tale by sharing one of his life's great tragedies. He felt completely misunderstood by adults his entire life because they mistook his drawing of a boa constrictor that swallowed an elephant for a drawing of a hat.

Do not have expectations

Do not have expectations that a project is going to come out the way you envisage it. Encourage everyone to make the card they want, the picture or collage they want. This is why we discourage the use of commercial kits. There is usually only one way to use them or you are not doing it "right." Pre-printed mandalas or other pictures are OK to give to people who are

too tired to think up anything themselves or who need the relaxation of just coloring in the lines.

Avoid doing the work for the patient

This reinforces that they are not an artist. However, if the patient is too weak to make art, often he can direct the practitioner on how to make something. "Make the card with that picture of a bird and inside write…" Sometimes when a patient is very ill, it may be too difficult to expend the energy needed to direct the practitioner. In that case it might be wonderful to make something as a gift for the patient. The point of the activity is to engage the patient as an artist. Always consider why you are making art for the patient. Is it because it is easier or are you showing off? Making art for someone can be a gift or an impediment to his or her growth.

Self-care

Even though making art with people is lots of fun, it is also hard work. Be aware that you will see and hear stories from people that will really affect you. It is hard to work with a cancer patient who is the same age as your daughter or looks like your brother. Make sure that you have someone to talk to about this in the hospital or the hospice. If there are other art practitioners, make sure you get together for supervision and the sharing of stories so that you can process your feelings and your fears.

Art-making will be good for you as well as the patients. Medical personnel can work through some of their own intense feelings through art-making. Sometimes the desire to serve, which is the reason most people go into medicine, gets lost in the technical approach. Art feeds the human soul and brings us closer to patients through meaningful interactions filled with presence, delight and play.

Supervision

Whoever you are—art therapist, artist, or other health professional—it is important, if at all possible, to have professional supervision. If you cannot find someone in your institution who has some experience doing this kind of work, get together with your colleagues who are interested and help each other. If you can find a professional outside your institution, even if you have to pay, it will be worth it. Working with patients is hard, and you need support. With supervision difficult experiences can turn into richly satisfying learning experiences. We have seen that the main area of concern for new practitioners is emotional support.

It helps to have someone to talk to who understands how difficult it is to be with someone very ill, to be turned down so often, and to believe sometimes that all you are doing is glorified babysitting. Keeping a journal in combination with supervision will keep you become aware of what comes up for you and help you express it, rather than bottle it up inside. Without an outlet, you might find yourself not wanting to do the work, though you could hardly wait to do it when you first began.

If possible, work with someone who knows the developmental stages and characteristics of the age level you are working with. Sometimes activities fail because they have not been customized to the age group or setting.

Take classes and workshops to improve your skills and explore new techniques, but most importantly do your own art. Practise what you preach and listen to your own heart; the hospital is a demanding setting.

Knowing when it is time to take a break (Suzanne speaking)

Several years ago, when my children were still little, I discovered that the work I had been doing for many years, was no longer appropriate for me. That does not mean I did not love it, or that I had gotten tired of it, but that as circumstances changed, I did not continue to adapt. One evening it hit me.

My husband and I went to the ballet to see "Romeo and Juliet." It was a fabulous production, with an extraordinary cast, set to Prokofiev's stirring and evocative score. Part way through the opera, in the middle of the beautiful love scene, I started to weep. Little tears kept flooding down my cheeks, unbeckoned and misunderstood. "How can I possibly be crying? It's so lyrical."

By the end of the ballet, I was inconsolable. My husband turned to me astonished, and asked, "What's the matter? You knew how this would end." I blurted out, "It's not Romeo, or Juliet; they're dead. It's Lady Capulet losing her children!" The death of her nephew was brutal, but the death of her daughter, too? It was more than I could bear. On our way out of the theater, my husband said the words I had not expressed, "It's time you took a break."

He had seen it coming. Even while crying my eyes out in a public place, it had not dawned on me that my work was behind my outburst. Months in the pediatric intensive care unit had exhausted me. I realized that I needed to work with a different population. I was able to go home to healthy, strong kids at the end of the day; the families I made art with were not. The truth is, I identified with the grief and torment of the parents I counseled. I was no longer clear and at ease as I listened to their stories and drew with them.

That afternoon, before the ballet, I had found myself working with two sets of parents on either side of a curtain. Both families had their children on life support. One baby was still unresponsive after many months and was undergoing daily infant stimulation, but so far without success. The child was essentially brain dead, but the parent's hope and desire to do everything possible was being heeded by the hospital staff. "Miracles do happen." On the other side of a curtain was an immigrant family. They had just decided that they would remove their child from life support and return to Mexico, and again a truth, over which I had no control, resonated in their voices too, "It is in God's hands. Miracles do happen."

Stories like this happen frequently in the hospital. We cannot fix, save or make the situation much better for those involved. We can, however, offer our compassionate support for them and for ourselves. Sympathy and empathy are very close, but there is a big difference. Sympathy is essentially an act of imagination that allows us to understand the patient's situation. Empathy, however, launches us over the precipice into taking on the patient's suffering; at that point we can no longer hold the space to compassionately witness their process, because we, too, are engulfed by the enormity of feeling. Only self-awareness can lead us to see when our boundaries are not clear. When our own radar is not clear, we need to trust our mentors and supervisors. Seek support, do art, meditate, regain your clarity—only then can you really help others.

Chapter 4

Everything You Need to Know about Art Materials

The following are basic rules for using art materials in a hospital or with any fragile population.

1. Use the best materials you can afford. Do not give people old broken crayons or crummy paper. Sick people deserve new, exciting, even glitzy materials because their appetite is diminished. You want to stimulate their interest and present a banquet table of wonderful materials. Be on the lookout for recyclable materials, and do not hesitate to solicit donations from local companies. The worst thing they can say is, "No," and if you have mastered rejection in the hospital room, asking for freebies will be a piece of cake!

2. Make sure the materials are safe and clean. Be very careful what you give to small children, those with dementia, or those with developmental handicaps, as they might put small or tasty items in their mouths such as beads, paste, clay or sharp scissors.

3. Unless you have special permission and training, do not enter rooms with precautions on the door. If a patient is immunocompromised, and you are allowed access, be sure to give clean (wrapped, if possible), brand new materials to the patient. Take the materials out of the wrapping and throw them away just before you enter the room. Then wash your hands before entering. In between seeing all patients, always wash your hands and clean the surfaces that will be touched by the next patient, such as markers or brush handles.

4. Use nothing that is toxic. Ever.

5. Be sure that you have secure storage for your materials. Space is at a premium in hospitals and if materials are visible and easy to get to they are often "borrowed," never to be seen again. If materials are locked away too securely, no one finds them.

Your choice of materials is, of course, dependent on what you are planning to do, how much storage you have as well as transportation concerns—how you are going to get the materials to the patients? So, as you begin to compile your supplies, do not forget to consider all of the factors above.

Basic art materials

A supply of basic art materials should include:

- Markers/felt tip pens
- Pencils
- Pencil eraser
- Pencil sharpener
- Drawing pen with a fine line
- Colored pencils
- Cray-pas oil pastels
- Crayola crayons—purchase a generous sized box. These really are the best. You can also get small boxes with four crayons that you can give away to patients along with sheets of drawing paper or mandalas to color in. This is an especially nice touch for visiting children.
- Prismacolor or Acquarelle watercolor pencils—these are great because they are so versatile. They can be used on wet paper for a wet-on-wet effect, or if they are dipped in water first, they look just like watercolor when applied, but are much easier to control than paint. Most people have never tried them, so it makes the experience new and more exciting.
- Tempera markers—these are no-spill bottles, filled with tempera paint, that feature specially designed tips that allow small children to paint without the usual mess of brushes. You can also get refillable tempera marker bottles that can be re-filled as needed and are more economical.
- Paper—it is important to have several weights of paper available, including heavy paper such as Bristol or card stock that can be used for book covers. Sometimes printers will give you off-cuts for free.
- Glue sticks and popsicle sticks—glue sticks are very handy, but sometimes popsicle sticks come in handy to spread glue around, or dot it on one small place without getting one's hands too messy.
- White glue is good for collage and glitter, but it does take much longer to dry than glue sticks.
- Scissors—have a few different pairs available, including those that make fancy edges as well as safety scissors for young children.
- Collage material includes a collection of cut out pictures, some of which may be glued to index cards, old art postcards and interesting images cut out of magazines such as "Communication Arts" and "National Geographic" can be especially rich.
- Model Magic is the perfect "clay" for the hospital or office. It comes in colors, it is clean and does not come off on hands or bedclothes. It can be sculpted and then air-dried. The 4 oz packages are most economical because they do not dry out so quickly. You can also purchase 1 oz packages in bulk, which are great for giving out to people for later use, or to visitors to invite them into the art-making process.

- Sculpey and Fimo are lovely modeling materials, but they are expensive and should be fired in the home oven. For a special project they are worth purchasing.

- Plasticene is an oily clay that many people find unpleasant to touch because it leaves a residue on the skin, but it models well. It is better suited to group projects than to art at the bedside.

- Modeling tools—clay tools and toothpicks, plastic knives and other simple "found" tools are a good addition to hands.

- Fabric and felt—have small pieces available that can be cut up for projects or collage.

- Needle and thread are handy for making books or sewing dolls.

- Magic Paper is fast drying, reusable paper that is used to test brush strokes with water. See Magic Paper under Icebreakers (p.79).

- Ephemera include things like little cut-outs, ribbon, a variety of "glitzy" materials such as glitter, sequins, buttons, feathers, ribbon that can be glued onto projects.

Many other art materials might be included such as Styrofoam for mono-printing, yarn, knitting needles, crochet hooks, embroidery thread, needles and fabric, beads for jewelry and findings (elastic string, fasteners, etc.).

Sometimes, it is best to put all the materials required for a special art activity, such as the Jointed Story Dolls (p.148), into a Ziplock bag.

A special note about kits

Generally we discourage the use of pre-made kits (unless they are our own). We want to encourage that "spark of creativity," which is the spark of life, to ignite. In *Creating Connection Between Nursing Care and the Creative Arts Therapies* (Le Navenec and Bridges 2005), Wende Heath said, "Making art or hearing music reminds us that no matter how ill or busy we are, we can always tap into the magic of our imagination. This frees patients from being just 'the cancer patient in bed 4', passive with no power, to the person who has cancer who still has an imagination, a creative spark. This spark can be utilized to tell her story, imagine her healing, aid in her recovery" (p.116).

Using a kit often just requires the patient to follow instructions. This is soothing to those who believe they have no talent, and it helps pass the time, but our goal is to get patients interested in their creative selves, which is certainly much more rewarding than a paint-by-number still life. We do make exceptions for the following:

1. Coloring books of mandalas or stained glass windows, for example. Sometimes all patients want to do is to color in the lines and be soothed. Stained glass window coloring books with parchment paper pages are particularly nice since they are easy to paint, and because the paper is translucent, the results are quite beautiful when taped to the window.

2. Unfinished wooden picture frames—these are not really a kit but are a different sort of practical canvas to paint and decorate. These are very popular with expectant mothers, who make them for their babies.

3. Models—teenage boys are very fond of model car or airplane kits. Sometimes if they are in the hospital for a long time it might be the only thing they are willing to do. Make sure they have the patience, skill and support needed to assemble the model, or it will be rejected as too hard.

4. Notched popsicle sticks—these can be used to build houses and structures. They, too, are very popular with boys.

The "Art Cart"

Although we call it the "art cart," the art cart is actually any container that helps you store and transport your art supplies. Not everyone is lucky enough to find or store the perfect trolley. We have used backpacks, rolling suitcases, and old med carts! We did try hand-held utility caddies—that was a disaster. The caddies looked just like the ones the phlebotomists use to draw blood. Children began crying as soon as they saw us.

The nice thing about a cart is that the patients can immediately see the enticing art materials, and the presence of the cart itself becomes a bit of an icebreaker. Unfortunately, it takes a lot of space to store a cart and the carts cannot easily be transported between venues. The suitcase on rollers has proven to be the most successful, because it is not too heavy, nor too big, to wheel about all over the hospital. It should have basic art materials and room for the special project of the day. So try out a few options; see what works best for you.

Chapter 5

Ready, Set, Go

Now that you know all about materials, what to do, what not to do, and are convinced that one of your patients will turn out the next Mona Lisa, read on…

Prepare yourself physically, mentally and emotionally before you greet your patients. If you are in a hospital setting, wash your hands before and after every visit. When washing, it is the friction and the time that matters, not the amount of soap. Wash you hands for about as long as it takes to sing "Happy Birthday." *Stay home if you are sick.* Hospitalized patients often have compromised immune systems and your little sniffle could have dire consequences. Take time to adjust to the rhythm of the hospital. Slow down, let go of the commute; take a walk, or do a grounding exercise and let go of all your worries.

People are very fragile and hypersensitive when they are in the hospital. It is important that the art practitioner is centered and completely present when entering a room. There is often a period of fear or excitement before entering a room. Who will be beyond the door? Will I be able to help them? Will they understand what I have to bring? Am I prepared for rejection, so that I do not take it personally?

Always remember that if you are frightened, the patient is always more frightened. You have the opportunity to bring them into the present moment so they do not have to worry about the future or their illness. You can model calm. You can model being centered. You can model presence. When you are with the patient, they should believe that you have all the time in the world—and so should you. Ask if you can come in. Sometimes you might never go any closer than the door and instead you might have a lovely short interaction just inside the door. If the patient is comfortable doing art, approach the bed and take a nurturing, comforting stance.

As soon as possible try to get on the same level physically as the patient because it can be intimidating to have someone stand above you. Pull up a chair close to the patient or ask permission to sit or perch on the bed.

If there are visitors in the room, try to engage them in the activity too. Often visitors do not know what to do in a hospital room and they fuss and chatter and exhaust the patient who then ends up entertaining *them.*

Preparing the room

Whether you are in a hospital room, an office or a church basement, it is important that the atmosphere is conducive to art-making. If you can find out anything about the patient first, it can be very helpful. Ask the nurse, or read the chart, if you are allowed. Then you can make informed choices when it becomes time to create.

You can expect lots of interruptions in a hospital room, but can often minimize them by asking the nurse to plan procedures before or after your visit. Often you just have to go with the flow and be very flexible. You can ask that the television be turned off, or if the patient is in the middle of their favorite show, suggest that you come back later. Sometimes soft, soothing music from a CD can help the mood.

Be prepared to set out interesting materials that are appropriate to the age and situation of the patient. It is like setting a fine table. Do your preparation before you get into the room so you know exactly where everything is and you are not fumbling around looking for materials.

Introducing the art

You would be amazed how afraid most people are of art-making. They seem to feel completely inadequate, as if you were asking them to do brain surgery with only a kindergarten education. Most people's last experience of art-making was in primary school when someone commented on the color of the dog they were drawing, when they were really trying to draw a pig, or told them to mouth the words in chorus, because they sang off-key. What they remember about making art was being embarrassed and ashamed. Oftentimes, before we even begin, patients, visitors and staff members are already cooing nervously "Oh, no dear. I can't draw, sculpt, sing, etc. My sister, cousin, grandmother…is the artist in the family."

If you ask someone if they *want* to make art, you will probably activate all those old unpleasant experiences, and they will say, "No!" Often therefore, we do not use the "art" word. Sometimes we say, "Do you want to make something with me?" "Do you want to do something creative?" "Can I show you some fun materials I have? Maybe you might want to make something with them."

Doing the art

You are there as a helper and a witness. It may be appropriate to teach a technique such as how to use watercolor pencils, but then get out of the way. The idea is always to encourage the patient to use the materials in a way that is satisfying to them. In art you are often making a product, but the emphasis should always be on the process. It is the process that gives you insight, and this in turn guides you in how to accompany the patients on their journey. It is the art process that ultimately brings the patient knowledge.

Being in the process and creating art at the same time is harder than it sounds. The ability to be with the patient, move the art process forward and come up with something that is satisfying or better, yet that brings insight and healing, is a skill which takes many encounters to perfect. Ah, but when it works, it is like dancing. It is magic!

When the patient is too ill or tired to do the art, but wants to be involved, the facilitator can become surrogate, creative hands. Let the patient pick the color or topic and then direct you to make the art piece. This should be very interactive. Instead of making choices for them, always ask, or gently suggest, for example, as an option, "Would you like one of these colors, or one of these?"

If the patient is very ill you can make them a gift. Cards, portraits and books that are made while the patient watches are often diversionary, and the gift shows them that someone cares.

Discussing the art

Occasionally, it is appropriate to talk about the art, but you can easily kill the magic by naming it. Instead, let the art speak for itself, or allow the patient to introduce you to the artwork. (Imagine how uncomfortable it would be for you, and how awful for them, were one to say, "What an interesting bird" when they were trying to draw a ballerina.) Asking the question, "What is it?" is equally chilling. Maybe the patient does not know what it is, or maybe there is no *it*. In any event, they should not feel compelled to name it just to please you. Everything has a story, whether it can be expressed verbally or not. You are the witness, not the creator.

What you do want to encourage is an open-ended discussion that invites disclosure but does not demand it. "Do you want to tell me about this picture or sculpture?" "Is there a story in this picture?" "I see that you have this large area of black in this mainly yellow picture. Is there a story about it?" "Where does your picture have the most juice?" "Is there a part of the picture you love or hate?"

Sometimes people do not want to talk about the art. They have said what they needed to say through the artwork itself. If that is the case, honor it, and let the art be.

You can also ask if the patient wants to hang the picture in the room or take it home. Sometimes they want to give it to you. This is OK, as long as you intend to keep it for yourself. You may not take a patient's work and display it anywhere in public without getting their express, written permission, even if it is just in the hall outside their door. It is lovely when patients make art and are proud of their achievements, but that is not the case with many patients.

Often artists and expressive arts practitioners come into the hospital and are disappointed if the patients do not do "Art." They feel that somehow they have failed the patient. We see the expressive arts in the broadest of terms. It means using any expressive technique to help the person in their healing journey. This may include nothing more than listening to their story. One of the interns at California Pacific Medical Center worked with a teenaged girl who was very ill and who, in spite of all treatments, eventually died. She had wanted to go to cooking school. The two spent hours together over the months the girl was in the hospital, knitting and watching cooking shows on TV. Through talking about cooking, many topics came up about her illness and possible death. The artist kept her company on her journey. In the end, it was the sojourn that mattered most, the gift of human connection at a vulnerable point in her life.

Chapter 6

Notes from the Practice

It is one thing to discuss theory, to make recommendations or give advice, but what is it really like to be with patients? Over the years we have worked with a variety of patients of all ages, genders and social backgrounds, and have been faced with such a multitude of situations that we cannot really generalize. Every case is different. However, there have been many sessions where we learned something important about the practice as well as ourselves and there have been instances where the work was so profoundly moving that these have become indelible in our memories.

Some examples may be considered "mistakes" and some great successes, but who can really judge? Each is an examples of a process and each has made us better practitioners and, we believe, better human beings—certainly more present and open to possibility than the first day we set out with brushes, pens and paper.

We hope that our adventures in the field will give you the courage to throw yourself into the mix. You now have the knowledge: a basic understanding of how art can be efficacious in healing, a long list of activities and tips for working with patients, and most importantly your own professional background and experience. It is time to trust your common sense, art know-how and intuition, just as we have. What follows is a series of anecdotes from our own practices that range from poignant to potentially disastrous. But no matter what we faced, our intention was always to be present and to connect with the patient. It is this core of presence that will help you navigate the terrain as you begin to gain your own expertise in the field.

Sometimes offering art at the bedside can be a frustrating endeavor. The hospital may be very quiet with many empty beds, or the patient population may not be inclined toward making art. On those days, we suggest you still make an effort to connect with individuals. Sometimes it may be nothing more than wheeling your art cart from room to room and engaging in easy conversation with patients. Not everyone is as excited about the art materials as you are, and it can be counter-productive to make assumptions about a patient and their desire to do art. It is important to give patients plenty of space and time to think about the possibility of making art. Our best advice is to let go of your own expectations.

Each of us contributed to the following case studies; the initials following each heading indicates which of us is speaking.

Facing artists: working with professional artists (SD)

I have had the opportunity to work with artists many times in my practice, but two visits in particular come to mind for me. Both were sessions with graphic designers who were extremely resistant to making art. The first was a middle-aged man who had recently been

given the news that he had pancreatic cancer. Not only was he still reeling from his diagnosis, but he was also trying to sift through reams of information about different treatment choices given to him by his doctors.

When I walked into the room, I had no idea what his situation was. I had not read the chart; the nurses had not spoken with me; I just poked my head in and saw a fellow quietly reading. When I suggested that we make some art together, he really snapped at me and told me that he was an artist and did not need to do any art.

Rather than leave the room, and take his comment at face value, I paused for a moment, recognized that here was a very upset man, and immediately felt a responsibility to help him. However, the truth is he just wanted to be left alone with time to process everything he had been told. He was not even open to talking to me, but the fact that he said that he was an artist had led me to believe that, of course, he would love to make art. Here was a great opportunity to pull out all the stops. Yet my expectations were coming up against his needs.

I left feeling thoroughly disheartened. Had I done something wrong? Why could I not help him? In that short encounter I learned the importance of letting go of my expectations. Expectations hold you back from being in the moment, because they tie you to the future. He just needed to be, and I was arriving with an agenda. Everyone you meet comes with a story, and in the hospital the stories are often dramatic and have already been repeated a hundred times to each specialist, nurse and intern. You might never know when you walk into a room whether someone has just had an invasive procedure, bad news or good news. You must just arrive open—to the situation and the individual before you. That is presence. That stance allows the patient to be heard. The next time I entered a room and the patient said, "Oh art, yeah…I'm a graphic designer…I don't need to do art…I do it all the time," I spent a little more time assessing the situation.

This gentleman was not angry and not directly trying to shut me out; he just did not see how what he did for a living could help… After all he did art every day and was still in the hospital. He was happy to relieve his boredom with some light conversation, and after a few minutes I decided to broach the idea of making art again. I turned to my Magic Paper, the most important icebreaker one can have on an art cart. (It is actually stiff, quick-drying paper that artists use to test brush strokes. See Magic Paper under activities, p.79.) "Have you ever seen one of these?" I queried. He shook his head. The great thing about Magic Paper is that the artist has complete permission to let go of the result, because the watery strokes on the board will evaporate in just a few minutes. Just the blank page is left. A graphic designer, rather than focusing on the artistic process, generally works in a very controlled manner where the end product is the most important thing. So this is quite different from what he would have faced in a professional capacity and because of that novelty there was a good chance that it might get him started.

He was intrigued. He sat in bed and made hundreds of little squiggles with a damp brush all over the page. As one stroke dissolved, he added another. After a few moments, he wanted to move on to something else. I suggested choosing three images out of the stack of post cards on the cart. He chose three and with each one generated a list of words that popped spontaneously into his mind. We turned these into a poem in free verse and he was quite moved by his own eloquence. He commented that he never knew that he was a poet.

As the session came to a close and I started to pack up, he returned again to the Magic Paper and asked if he could compose a poem about the little squiggles. His word list included

worms and parasites and tunnels. He stopped. He looked at me with wide eyes, his mouth open. "You know, I have intestinal adhesions and this is about my seventeenth surgery... I read this article about these worms that you can take. They're a parasite, but apparently they can really help people with intestinal problems... I think that's the answer for me. I'm going to try them and look up that research as soon as I'm out of the hospital."

In one session he moved to a place of insight. Possibly he had been considering the worms unconsciously all along, but it was the little squiggly doodles that led him toward a sense of agency and empowerment in facing his own disease. As I left, I was so glad that I stayed and encouraged him to try picking up a brush and water.

He taught me that it is a good thing to bring artists activities that may lie outside of their comfort zone—unexplored media such as poetry, movement or music. The truth lies in creative exploration and connection; it is good to get away from focusing on the finished product—which is precisely how professional artists are trained. In their field, it is the final product that is appreciated, not the process: we may just have to turn things on their heads and, who knows, doodles might lead to cures.

There is a sitter in the room: working with aggressive patients (SD)

When patients are challenging, or need 24-hour observation, the hospital or family might decide to place a sitter in the room. A sitter is very helpful, for example, in a situation where a patient tries to remove his or her IV lines or is physically aggressive.

If you see a sitter outside a room it is always good to talk to them first about the patient. Oftentimes patients with sitters are not the best candidates for expressive arts activities. The patients might be violent, or possibly psychotic. Expressive arts are always contra-indicated in psychotic cases.

On one occasion I entered a room with a sitter. The patient had been violent and was still slinging a string of slurred invectives at the ceiling. Many expressive arts practitioners might have turned around and left the room, but I decided after a brief conversation with the sitter that a little art might actually help pacify the patient. The patient, whom I will call "Jeanie," was a developmentally disabled adult and probably quite frightened about being in the hospital.

As I approached her bed she swung a leg toward me. I kept my distance and I addressed her by her first name, Jeanie, from several feet away. I began by asking her a few simple questions: her favorite color, whether she liked flowers or animals. She did not respond, so I started a very gentle, one-way conversation in front of her, providing the answers myself. She became increasingly less agitated with nothing more than the constant patter of dialogue. Finally, her breathing became regular and then she turned on her side to get a better look at me. Very softly, I told her that we were going to make a garden right here in the hospital room. Children generally love pipe cleaners, because they are colorful, easy to work with and have a fun, inviting texture. Also they do not look like anything a doctor or nurse might carry and could never be mistaken for a medical instrument. So I thought they would be a good choice for her.

Still careful not to get too close, I began to form a pipe cleaner into a flower, using my favorite color. Then I made leaves and a stem and attached the flower to her bed rail and

retreated again to a safe distance. I kept up my dialogue the entire time. One after another, I added a flower to the garden. She was quiet. Then Jeanie asked for another and then another, and began to direct me as to which color to use and where to put the flower. By the end of our session she had a bedrail flower garden and we were having a simple conversation that lasted nearly 40 minutes.

The sitter commented that it was the most relaxed Jeanie had been for the last two days, and when the nurse came in to check her vitals, which had been an ongoing travail during her stay, Jeanie held out her arm for the blood pressure cuff and allowed the nurse to tuck the thermometer under her tongue without spitting it back out at her.

I cannot say she remained a model patient, but I can say that her garden brought a smile to everyone's face. When she left, the nurses helped her carefully remove each flower so that she could take her garden with her. That is the joy of imagination: pipe cleaner flowers never stop blooming and they need neither soil nor water. Best of all Jeanie had a little treasure to take to her own bed at home.

Pediatrics (SD)

Pediatrics is always an adventure. There is no "right way" or "wrong way" to be with a child, there is only presence, and children are our best models for the quality of presence. They are a great inspiration for the expressive arts practitioner; they tend to be in the moment and remind us that we can let go of the conversation we just had in the elevator, or forget the parking ticket that did not get mailed. When you see children at play, nothing else in the world seems to matter to them. Their game of the hour with all its intricate rules and exceptions is their reality. It is also their work. Through play they begin to learn the boundaries of the adult world: how communities function, how individuals relate to one another, what is fair, unfair, what is kind and what is cruel, etc. Play is essential to their development. When play is taken away from them, as it often is in the hospital setting, they are stripped of their opportunity to play and imagine. Instead they are given hours of television, and instead of friends traipsing down the corridors to visit, they are "seen" by a steady stream of medical professionals. The expressive arts are an easy way to bring play back into their lives, and imagination is the best tool they have to overcome the boredom, fear and discomfort of a hospital stay.

Mrs. Post Lady: working in a sterile environment (SD)

I received a call one afternoon before arriving at the hospital. It was brought to my attention that a little boy, not more than six years old, was neutropenic after his last round of chemotherapy. Neutropenia is a condition that affects the blood and greatly reduces an individual's ability to fight off infection. In extreme cases a patient might be isolated and put in as sterile an environment as possible in order to limit exposure to pathogens. This child, "Jonathan," had been in the hospital on and off over the last year, although I had never seen him before. I was asked to please stop by, but I had to wear a mask and gown and only use brand new materials that had not been handled by anyone yet.

I came prepared with a new array of markers and some paper, but I was not too happy about the gown and mask get-up; I would set off alarm bells for the kids. With children, it is especially important to look like a regular person, not a medical professional, because the

people who wear scrubs, gowns and masks usually perform invasive procedures: they want blood or they give injections. I prefer to be a bit more anonymous in the hospital. Somehow, it is easier to slip into a room when you are wearing a skirt and sweater. You look like someone who is there for a bit of conversation rather than a procedure. Now here was a little boy, very sick, in isolation, withdrawn, and probably frightened, who needed companionship and a chance to play.

Then it dawned on me. I could make this get-up my own special uniform. Who says I have to be a doctor or nurse? I could be someone else in a uniform—a postman, for instance. I just had to make up the rules for our game. I grabbed an extra gown, tied it into a sort of satchel, and voilà—neither sleet, nor snow nor rain would keep me from my route. When I opened the door, Jonathan cowered in the bed. I stayed by the door and explained that I was a postman and I had a letter for him.

Quickly I scribbled fake writing (I was not sure if he was reading yet) and added a picture of a dog. I asked if I could deliver it, but stepped back swiftly to my position by the door. He looked at it, and looked at me quizzically. I was not really sure whether this was going to work at all, but it was just the two of us… I asked him if he wanted to send a letter to someone. I gave him a pen and some paper and he drew a person and some squiggles. I delivered this one to myself—we played for quite a while. I would write and deliver to him, then he would write and I would deliver to myself… Eventually, we got to the point where it was OK for me to stand near the bed.

He dictated several letters to me. Sometimes, when he got tired I would help with the pictures. After quite a long time, I realized that other children were waiting for me too. "I have to go now," I said, "I've got other letters to deliver." I left him with a big pad of paper all his own and the beautiful new markers in rainbow order. He handed me a blank piece of paper and asked me to bring him a letter.

Two days later I came back and when I entered the room as Mrs. Post Lady, he waved a stack of papers at me. He had written letters to all sorts of people—nurses, attendants, and doctors, and even though he did not know everyone's name he described them to me. "She has pants with purple and yellow cowboys on them and he has a tie with a sailboat on it and he comes at night with my Jell-O. I like the green kind."

I did my best delivering letters, and for weeks, long after he had left the ward, there were little, scrawly notes tacked up at the nurse's station, each one signed with the two words he knew how to write, "Love, Jonathan."

Shock and awe: working with teens (SD)

"Chris" was another memorable pediatric patient. The nurses tapped me on the shoulder the minute I walked onto the floor and asked me to visit the 13-year-old boy in Room 432 as he had told them he would like to make some art. I trundled my cart down the hall and rolled right into the room. There is this clever way of getting into a room: you push the door open with your bottom and then swing the cart right round in front of you. It is rather dramatic and noisy, but a fun, attention-getting move for the kids… I was ready to start and before even introducing myself, other than "Hi, I'm here to do some art with you," I had pulled out some toothy paper and watercolor pencils. As I held them up in my hand, I suddenly realized both of Chris's hands were veritable basketballs of bandages and tape. There was a slight moment

of recognition where he noticed me catch my breath, but rather than succumb to my feelings of "Boy, did I blow it," I said, still in a jolly voice, "Let's see your feet. Because we are going to paint."

He gathered the bedclothes up with his elbows and exposed two bare feet. He still did not say a word, but swung his legs over the edge of the bed. They did not quite reach the ground comfortably, but it did not matter because there had to be room for the brush anyway. He laughed when I put the wet brush between his toes. It was quite a challenge for him to do anything at first other than sweeping strokes, and there were lots of spatters and spills, but once he got used to it, he wanted to try something with more control. I switched the brush for the watercolor pencil of his choice.

It turned out art was his favorite subject in school. In his spare time he drew inventions and spacecraft and aliens. He started to make big curved marks on the paper and as the drawing developed it was clear that what had begun as an abstract was now a set of talons surrounded by teardrops. He started to cry.

He was afraid. He had blown off several of his fingers while making a home-made rocket in his back yard. They were able to attach some of them, but his hands would never be the same. He was ashamed of his disfigurement and cried and cried until he was exhausted. I sat with him for a long time, in silence, witnessing his pain.

He started to talk about his drawing. His hands might look like those claws; they might be hideous; he might as well be an "alien from outer space." After a few minutes his parents entered the room. He gave me an insistent look that meant, "Please pick up the paper, *now*." I took away his drawing. His mother was very chatty and started straightening up the room. It was clear that our conversation was over.

After introductions, his Mom told us that he would be moving tomorrow to a different hospital, closer to home. I was disappointed. I had hoped that we might see one another again as our visit was cut short by the arrival of his parents. He asked me if I would be coming again.

I walked over to the nurse's station to find out more details about his transfer. It was true: he was only at our hospital for his surgery and would be moving as soon as possible to a facility managed by his insurance company and the outcome of his surgery was likely to be very good. All I could do was to put a note in his chart requesting follow up visits from a social worker and recommend that he be seen by a child-life specialist. I left, unsure whether he would get the help I felt was beneficial, but satisfied that at the very least, he had spoken with someone about his fears.

Sixty Five Roses: working with the chronically ill (SD)

I think one can safely say that the goal of most hospitals is to move patients through quickly. Luckily, most patients I see stay only a few days and then go home. Occasionally, I see patients with terminal or life-threatening illnesses who, unfortunately, need to return to the hospital frequently for care.

I was lucky enough to make the acquaintance of identical twins in their twenties, Charlotte and Vanessa, who had cystic fibrosis, or "CF." The most prevalent symptom of this genetic disease is lung failure, and although treatment has improved and patients have a longer life expectancy and many make it to their mid-thirties, it is still ultimately fatal.

The first time I met them they were in a double room that had been transformed by scores of their own colorful drawings, taped up to the walls in haphazard gallery style. They had already been in the hospital at least a week. When they saw the art cart they were elated. Vanessa was very excited about a packet of little googly eyes and while she was busy inventing something that she could attach eyes to, Charlotte took me on a verbal tour of the drawings.

The twins were no strangers to art in the hospital. Their love of drawing began when they were little girls. CF is an inherited disease and parents usually know when their child is quite young that he or she will lead a different kind of life to that of other children. Luckily there is good support for kids with CF—everything from summer camp programs to support groups—and in one of these early programs they started to draw.

Cystic fibrosis is a big word for kids to pronounce, so Charlotte and Vanessa were taught like many other young CF patients to call it Sixty Five Roses. I was struck by the enormity of the image. A disease that might be called a curse was in fact a gift—a big armload of fragrant, long-stemmed roses, the kind one could imagine being delivered to an operatic diva or ballerina in a swan tutu. Vanessa and Charlotte lived every day as if it were a gift, and their enthusiastic appreciation of life and everything creative was inspiring. For them, hands were always clapping, cheering them on with standing ovations. They deserved the applause, because they had crafted a life for themselves in the face of a daunting diagnosis that was all about living fully, sincerely, in the moment. It was an honor to share the creative process with them.

Since they were little they had used their drawings to inspire other children. These they had turned into Xeroxed books—"I Hate When That Happens" and "Sixty Five Roses"—both of which they hoped to market to raise money to help find a cure for CF. "I Hate When That Happens" lists all sorts of childhood mishaps such as:

Toasting Marshmallows is such fun,

Unless they fall before they're done.

I HATE WHEN THAT HAPPENS

Gleaming Icicles I gleefully lick,

Only to find my tongue to stick.

I HATE WHEN THAT HAPPENS

…and it ends with "We always have friends who understand, And are always willing to lend a hand. WE LOVE WHEN THAT HAPPENS."

There is no doubt that the twins had tremendous support. I met their mother, other close family members, boyfriends and girlfriends. They were surrounded by a network of loving support and it was clear that they had always had this buoyant cushion of love underneath them through their entire lives. How lucky they were.

Their wonderfully optimistic little book, "Sixty Five Roses," dedicated to "all the little flowers and the great oaks who love them" is a poignant story about a little flower, aware that her life will last only a season. She lives in the shadow of a great, aged and wise oak. It was a bittersweet moment as I turned the pages, because it was clear that the girls understood the

fleeting nature of life; they were both the wise old oak and the little flower. What they never verbalized in our sessions they continually expressed through poetic language and watercolor.

> Deep down she knew that her time would be short in this world that she loved. She wept. "Please don't cry little one"…It was the gentle voice of the wise old oak…

> Why do I live but a short time while the ivy on the walls grows on and on? "But that is it, little one. Ivy works and works, never stopping to enjoy the beauty that every day holds…What about the roses?…Yes, little one, they are indeed beautiful, but hidden beneath that beauty are thorns. It is hard to hold something so sharp close to your heart.

Our sessions together were always a joyful, flat out, charette of art-making. As their disease progressed, the hospital stays became more frequent and eventually both girls passed away. I remember vividly the time we had a luau in the hospital room. The girls had planned a trip to Hawaii, but were unable to make the trip. We decided that we would make Hawaii in the room. I ordered leis from the florist and we put up posters and drawings with palm trees. We even tried to make a palm tree out of construction paper. We had travel films and fun snacks. Rather than sit in the room and feel sorry that the trip was cancelled, we celebrated together and in our imaginations traveled to Hawaii.

The twins were never afraid to play, never afraid to imagine, and never questioned the meaning of their lives as the end drew near; they focused through every difficult breath on loving and being loved. They had already discovered that, like the little flower in their book, they had blossomed fully and brought love and joy to others. For them nothing else mattered. "Some things are placed on earth to show others how precious each day is, whispered the old oak. She understood, smiled and was happy."

When is a circle *not* a mandala? (WH)

Often when you read this kind of book you assume that every exercise should be a triumph, because the authors are so fabulous and experienced (well, partly true). We constantly vary exercises to fit different patients' needs, the mood of the day, the materials on hand, the time frame available, etc. We have to be adaptive and our work has to fluctuate with the tide of changing circumstances. We often change course, right in the middle of an activity, if it is not going well, or even drop it entirely and try something else. Sometimes we just bomb. The following is an example of how I did not assess my population or the project thoroughly and how I missed by a mile.

At the time I was working at a residential treatment facility for severely disturbed boys. Another therapist and I were charged with leading a group of residents who had been sexually abused. The boys knew why they were to be included in this group and their level of anxiety and nervous tension led them to be hyperactive and generally non-co-operative. I realized that they would need time to calm down at the beginning of each session. I was eager to come up with a regular activity that would not only calm them down but also provide continuity. I envisaged some sort of ritual that could be repeated each week. I thought that working on a mandala might be a way to calm and focus them. A mandala is a circular form with a center point. It can be as simple as a circle or as complex as a labyrinth. The symbol is found in many ancient religions and is commonly adapted for use in the expressive arts as a tool for exploring

the self. I thought it appropriate for me with this group, as the boundary is firm, the circle is integrating and it had worked well for other populations.

I created mandala forms, large circles drawn in the center of 8"x12" pieces of paper, that they could color. I carefully placed these mandalas, as well as a handful of markers, in front of each child. Within minutes the boys, who had no idea what a mandala was, saw what they were familiar with—a hole. They began drawing dirty pictures illustrating what could be done with and to—the hole. The accompanying vulgar language got way out of control. Their behavior escalated and we nearly had a riot on our hands. One boy got so excited, he climbed onto the table and jumped about. I eyed my fellow therapist, "Looks like we better switch to Plan B." We proceeded to stop the group and corralled them back to their houses. Plan B may not always have to be that drastic, but it is always good to have at least one other option available.

"Cool" mandalas: working with patients who do not want to do art (WH)

A teenaged boy refused to have anything to do with art-making. He was very ill and was very invested in being normal and "cool" in spite of his hair loss and other signs of his advancing cancer. We suggested lots of activities and he turned all of them down because he was afraid that they would not turn out right. But he still enjoyed our company.

He complained of not being able to sleep, so one of the interns left him some coloring book mandalas and some colored pencils—just in case. Probably out of desperation, he tried them one night and found coloring very soothing. Thrilled, we brought him better pencils with more colors. He colored many of the mandalas and we put them in a notebook so that he could show them off to visitors and staff. He began giving them away as presents. He took pride in his skills, and while he was with us he was able to master mandalas even if he could not master his own fate. We gathered all of his work together in a notebook for his parents so that they could remember his new found pride, strength and creative spirit.

Just don't call them dolls: working indirectly (WH)

Remarkably enough, I continued with the group of boys who had been victims of sexual abuse. One of the most successful projects was making worry dolls. Boys often make wonderful creatures (do not call them dolls) such as action figures, Indians and heroes. This particular group loved the project and were very forthcoming when talking about their wishes and worries. We learned so much more about their hidden life, things we would never have been privy to had we asked directly. This is an example of what I call "side-door therapy." While you are just sitting there with the child, chatting about the doll (or any other art project) things just bubble up. "I see you have covered your creature completely with feathers. Can you tell me about them?" and still engaged in playful, magical thinking, the child speaks directly to you through the doll, "My feathers..." Boys hate the front door but will often open up and share feelings through the side door. This is why making things (art projects, gluing wood, etc.) is so helpful in getting to know them; they often speak through action.

Dolls are universally understood across generations and cultures. The doll can break down other barriers, cultural as well as emotional. In the hospital we often have patients who do not speak English. It is easy to show them how to make the dolls. Once a whole family of Native Americans turned the dolls into "spirit dolls." Each one of their creations became a healing totem for their sick relative. Another time, I came across a couple in the maternity area waiting room. They spoke only Spanish, but seemed open to making a doll. They made an angel. Only later did I find out that they had lost a child. So many needs, desires, wishes and worries can be expressed through these little dolls.

Green man: working with the dying (SD)

When I arrived on the floor that day, it was very quiet and the nurses did not have any leads, so I just started to walk from room to room. There were lots of empty beds and patients were either sound asleep or not too interested in my offers. Then I came to a room where a man with a long, grizzled beard was lying in the bed next to the door. I decided to go in. As a nurse passed the doorway she seemed very surprised that I would go in. She told me how he was a homeless man in liver and kidney failure who kept trying to pull out his lines and he would probably not live for more than a day or two. Sometimes he was lucid and sometimes not.

I decided to see if he was up to talking. As I approached the bed he whispered his basic information to me: name, age, etc. I let him know that I was not a doctor or nurse, but I was glad to know his name and I was just going to keep him company for a little while. He was in the last stages of organ failure and his skin was yellow-green. Even his eyes looked yellow.

I thought that maybe I could make a "wish doll" with him. (See worry doll in the list of activities, p.63). A wish doll is simply a clothes peg or pipe cleaner body with tissue paper clothing. However, tucked around their torso is a little slip of paper with either a wish or a worry—something secret. That way the doll, rather than the dollmaker, can hold the worry. As "Joseph" was too weak to construct the doll himself, I offered to make it for him. I asked him for his wish so that I could wrap it around the doll for safekeeping.

He tried to grab the bed rail and pull himself to the edge of the bed. I leaned down and he whispered in my ear "Peace." I wrote the little note aware that this was probably his final wish and with a certain solemnity spread out the rainbow of tissue choices before him like a giant deck of cards. He pointed to the most acid, absinthe green one could imagine. The color was a reflection of his own hue. Our session had taken on the tone of a ritual. I worked very slowly and deliberately making the doll for him. He watched everything intently. Using pipe cleaners, I then attached the doll to his bed rail. It perched there—simple and eloquent, and it carried his wish for peace. He lay back in his bed with a smile and thanked me. He did not want to do anything else. I sat with him in silence for a bit and then, as he drifted off to sleep, I slipped out of the room.

Later that day I had occasion to pass by his door several times. Each time he waved at me in the hall. All I could clearly see was a long arm encircled by its ID wristband and a shadowy space beyond, but I knew he was thanking me again. I waved back.

He passed away the next day, alone. I could not help but think that making the little green doll was one of the last meaningful contacts he had had. "Green Man" helped me to realize that every moment is precious and that life seems even more fragile in the hospital setting.

When I think of "Green Man" I am reminded of the story about Alexander the Great who asked to be buried in a coffin with holes in the sides so his arms could stick out. He wanted to show the world that even though he had conquered all there was to conquer, he still left this world empty-handed. Green Man came to the hospital with nothing; we shared only one short visit and then he was gone. It all boils down to presence—presence and connection—this is really what matters.

Lady sing the blues: working with unexpected outcomes (SD)

For quite a while, I led an expressive arts group for severely depressed seniors as part of the outpatient program at Marin General Hospital. Programming was always fun because I knew from week to week who would be there. Occasionally we would gain a new member, but the group composition stayed fairly steady for several years, so it was easy to plan ahead of time.

This was the second visit by a new member, "Paulette." Her first session she spent most of the hour watching the group because she was a little disappointed with her attempts. I hoped that this week I could encourage her to join in. I had been bringing a series of "limited" palette ideas each week. Once we explored the hot colors, another time black and white, and this week was finally going to be the cool colors.

The group in general was not too keen on talking about their depression and I thought that they might be encouraged to open up if they were restricted to using blue. There are so many associations between the color and depression: feeling blue, having the blues, singing the blues, etc.

So I laid out large sheets of white paper, blue and cool pastels, markers, pencils, crayons, glitter, construction paper…everything I had that was blue.

The session started off very quietly. You could hear everyone's breathing and it seemed to drag on—one minute felt like five. Then Paulettte started to hum and someone else joined in—"Blue Moon." Then the lyrics started. They colored more enthusiastically and, before I knew it, the drawings were abandoned and I had a real sing-along on my hands. We sang "Blue Moon," "Blue Suede Shoes," "Blue Hawaii" and plenty of other old time hits I did not know had "blue" in the title. Everyone was smiling and laughing; Benny Goodman would have been proud. If the men had been ambulatory enough we surely would have had a swing dance!

The seniors loved that session. When are we going to have more music? When can we sing? I promised them we would sing in the next session and for months our hours together involved music. Yet, we never did get to a discussion about depression. I had expected one thing and they took it somewhere else entirely—to a place I had not been sure they could really get to—a place of spontaneous joy.

The seniors were always teaching me something. Not only did I add a few new "hits" to my repertoire, but I also learned that the artistic process is what leads the session. The process itself is the guiding force. I must hold a safe space for the participants—a space that is respectful, has boundaries and is supportive. I do not lead the process; rather, it unfolds out of the artist's work. It seems that whenever I have had an expectation of where we should go, the art takes the participants to where they really need to go—and that is exactly how it should be.

Another time I came in with a recording of beautiful, lilting, transcendent orchestral music by Ralph Vaughan Williams. The week before, the group had mentioned that it would be nice

to do something relaxing so I set out watercolors and was looking forward to a serene, restful session. It was so restful that all the images were floating off the edges of the paper—disconnected and isolated. Then I realized what was going on. This piece of music inadvertently accessed what we did not get to with the blue palette. After a quick discussion, the social worker and I cut the art and then steered the group toward a discussion. It was a fruitful day. The time was right. It just needed Ralph Vaughan Williams, and not Elvis Presley, to allow their depression to speak.

Beam me up: working with older clients (SD)

One patient in the group, whom I will call "Jim," suffered from the early stages of dementia as well as depression. In addition to the weekly sessions he also came to us occasionally for respite care. He had difficulty concentrating, rarely drew more than a simple wavy image on the paper and barely joined the group in conversation. Yet, every week he would show up for class. Transportation was provided and there was always food, which is a real draw for seniors. I often wondered if he came because he actually enjoyed it or because he liked the peanut butter and jelly.

Every few months we would have an "art party" at our weekly meeting. We had special party snacks and instead of cut up fresh fruit or juice we would offer pretzels or chips. We played lively music and engaged in some sort of festive endeavor, usually a group project such as a mural.

This time, however, I was inspired by a Halloween costume I had made for my daughter—a Pippi Longstocking wig, complete with upturned braids and bows. I had had to buy several large packets of pipe cleaners in order to have enough red ones for the wig and I was left with a pile of lurid, bright pipe cleaners in every hue but red!

I decided that we should make party hats for our event with this assortment of leftover pipe cleaners. The seniors were delighted. We all sat at a long table with piles of pipe cleaners down the middle instead of decorations. They fashioned crowns and clown hats, pointy hats and wide-brimmed sun hats…some were quite elaborate, some were even dignified and restrained. Jim, however, unlike previous classes, dove in with enthusiasm. He worked furiously with an animated face the entire session and a determination I had seen in only a few of my most dedicated patients.

At the end we all sat back with our "crowns" atop our heads and one by one told the stories of our hats. As we proceeded round the table Jim could not control himself any longer and blurted out, "I've made antennae…a special hat with antennae so I can beam up to my wife in heaven!" He wore them so proudly, smiled with such warmth and did not want to take them off. It was the liveliest he had ever been and the group whooped and hollered with him. His delight was infectious.

Just a few weeks later, Jim did not show up for class. The social worker took me aside to let me know that Jim had passed away. I paused for a solemn minute, but then began to smile with a grin that seemed out of place to my colleague. We set up for our next class. When we announced to the group that Jim had passed away, they smiled, then started to laugh and finally burst into simultaneous, joyful exclamations of "Beam me up, Scotty."

Chapter 7

Activities

The expressive arts activities are divided into three types: icebreakers, media-based activities and themed activities. Each entry begins with a suggestion as to whether the activity is best suited to art at the bedside or groups and/or individuals. We also make suggestions for specific age groups such as seniors, children or teens. These often include guidelines as to age-appropriateness, such as six years and up, or twelve years and up…but each individual is different and you should feel free to adapt the activities to any situation or for any individual you feel would benefit from the activity.

Icebreakers are short and can run between 15 to 20 minutes of activity time. They are the easiest introductory activities to use with new or reluctant patients, or those with a short attention span. The other two—media-based activities and theme-based activities—generally require more time to complete, approximately 30 to 60 minutes, plus set up and clean up time.

Media-based activities are the freest in approach, without any guidelines other than how to use the materials. These are good both for newcomers and for those already at ease with the artistic process. Many patients may not have had any previous experience with art materials, such as watercolor, for example, and just getting acquainted with paints, brushes or block prints can benefit them enormously. These activities are also very good for those who are comfortable with the blank page and are raring to begin. There are no boundaries here, other than creativity, common sense, courtesy, presence and the edges of the paper!

Themed activities, on the other hand, have specific directions and an agenda. They tend to lead the patient into a particular arena for reflection, such as pain, relationship, the self, etc. and often depend on suggestions made by the facilitator at the beginning of the session as well as during the art process itself.

All of the entries include a list of suggested materials and, if appropriate, variations on the initial exercise. There is also a short section of pointers that might relate to special support for particular populations, such as safety for children and seniors, or additional information that might enrich the experience of the activity. At the back of the book, we have included an index of all of the activities divided into types, for easy reference.

So, thumb through. Ear-mark a few. Write off others. Be inspired. Choose the most appealing ones and get to know them well. It is always good to have a few "tried and true" projects that form the backbone of your expanding repertoire and also somewhere to look for inspiration when you need a change. This is your source book and, at best, it is just a starting point to explore possibilities.

Icebreakers

Cards

♦ ♦ ♦ Group
♦ Individuals
↩ Bedside
▪ All ages

Materials

- Heavy card stock
- An assortment of pictures cut from magazines
- Glue stick
- Pen
- Colored pencils
- Envelopes
- Stamps

Cards are a universal form of connection. They can be used for celebrations such as Valentine's day or Mother's day, or even Christmas or Hanukah, or to send wishes for a speedy recovery and to express gratitude. In a hospital the patient is isolated from the comforts of home, as well as from friends, family and colleagues. Illness does not stop for the holidays! Traditionally, it is the patient who receives cards, but how wonderful it is to give the patient the opportunity to reach out and connect with those who are far away. It is also good to remember that for the very ill a telephone conversation can be exhausting. A card allows them to connect with an economy of effort.

Variations

In a group setting it is fun to make block-printed cards by etching a design into a small piece of Styrofoam with a pencil (see Media-based techniques: Styrofoam printing, page 97, for complete instructions). This is too messy to do at the bedside, but perfect for a group setting when there is plenty of time and space to set up, play and clean up. Each patient can make many cards this way in one sitting, and in doing so delight themselves as well as the recipients. Stickers are also fun and very easy to use. Rubber stamps lead to all sorts of creative possibilities, but they require more strength and a flat surface.

Pointers

Provide a choice of illustrations or photos that have been cut out of magazines. It can be difficult for patients to manage scissors if they have an IV or do not have the dexterity or strength to cut. Also, magazines are distracting! If there is an interesting picture to which the patient is drawn there is probably a good article alongside… So, provide all the materials ready-to-go; you may need to remove the lid from the glue stick, for example, or even do the gluing yourself. You can even make the card completely under the patient's direction. It is helpful to keep your own selection of images divided by age or interest. We keep a stack of images good for all ages and have special envelopes filled with images we think will be exciting for children, teens, adults or seniors. It is also important to have images that are multi-racial and demonstrate ethnic diversity and different holidays.

Collaborative scribble drawing

♦ Individuals

↩ Bedside

I+ All ages

Materials

• Paper

Choose one of:

- ◦ Markers
- ◦ Colored pencils
- ◦ Paint
- ◦ Crayons
- ◦ Pens

Drawing together is a delightful way to engage young or old who are shy about their ability to make art or are unsure about you. Make it a game.

The patient begins by drawing (scribbling) any which way on the paper even with their eyes closed some of the time. The facilitator then creates a concrete image from the scribble. Work can continue with the scribble by coloring in the spaces or making up a story about it. Other scribbles can be added and the roles can be reversed.

Finally, the patient can make their own scribble with their eyes closed and then make something out of it. This can be a good launching place for making a more elaborate drawing or talking about something the scribble brought up.

Collection of objects

† Individuals

↩ Bedside

1+ All ages

Materials

Collections of any sort, such as:

- Buttons
- Beads
- Rocks
- Fossils
- Feathers

Present a small collection of interesting objects to the patient. Ask the patient to choose a few he/she particularly likes. Allow the object to draw forth conversation. This is a good way to open up dialogue.

Teenagers always do better with something in their hands, especially boys. Fiddling with a rock somehow eases conversation. We often offer play dough or Model Magic, in addition to the objects, just to give the boys something to do. Girls like buttons and beautiful gemstones. Seniors are often stimulated by old buttons.

Pointers

Do not give small objects to any child under six. Eye–hand coordination should be good. Be cautious with anyone who might have a diagnosis that would alert you to eye–hand coordination difficulties, such as a stroke patient, the aged, a cancer patient with neuropathy, a Parkinson's patient, an Alzheimer's patient, etc.

Creating for the patient

✝ Individuals
↪ Bedside
[1+] All ages
☑ Can be made for the patient

Materials

- Paint and paper, or
- Pipe cleaners, or
- Model Magic, etc.

Generally, it is preferable for the patient to make the art themselves, but there are a number of reasons why your doing the art for them is a good idea:

1. They are too sick or without energy.

2. They are afraid to make art.

3. They are suspicious of you and want to try "this art business" very slowly.

4. They have a disability which prevents use of their hands.

5. They are encumbered by medical equipment.

Sometimes, it can be wonderful to show off your considerable talents and make a present for the patient. This is especially true if you draw portraits or cartoons very well.

Whenever possible, make it a collaborative effort. You could do the actual constructing, while they choose the subject and the materials. You can do any activity that is of interest to the patient. A few to consider are making cards, making hats, making animals with pipe cleaners or Model Magic, or drawing a restful "vacation place" away from the hospital. An alternative is to show them all the possible art materials on the cart to engage their interest.

The idea here, as with any icebreaking activity (see pp.57–85), is to join with the patient and open up the dialogue. Eventually you want to encourage the patient to make art himself/herself. Sometimes, all it takes is walking them through the process and they are ready. Other times, they just love to watch you, and your giving them the gift of the project is what will make them happiest, or most comfortable.

Doll-making: wish or worry doll

♦ ♦ ♦ Group, including family members or friends
♦ Individuals
↩ Bedside
I+ All ages
☑ Can be made for the patient

Materials

- Tongue depressors, old fashioned clothes pins or popsicle sticks
- Colored pipe cleaners cut in half
- Fabric which is colorful and varied, cut into approximately 2"x 2" square
- Small strips of colored paper
- Clay or Model Magic
- Pens and scissors
- Glue sticks
- Feathers, glitter, fake hair, ribbon, sequins, googly eyes and anything that is appealing that can be glued onto the doll

These are easy and delightful dolls and are universally loved by everyone, even the most reluctant of art makers. They can be made in 20 minutes and talked about in 10 minutes. For groups we often lead them into the activity without announcing what is going to be made. We use the word doll only with those who like the idea of making dolls (not teenage boys, and not some men and some women). If you use the following sequence of instructions precisely, everyone will make a doll in spite of himself/herself. We say:

1. Choose a popsicle stick (or tongue depressor or clothes pin).

2. Choose one pipe cleaner.

3. Choose one piece of fabric (some people obsess and want more than one; it is ok).

4. Choose one strip of paper.

5. On the strip of paper write either a worry or a wish. It can be a big or little worry and it is often good to choose something you have very little control over. No one will see your worry or wish.

6. Take the paper with the words on the inside and wrap the paper tightly around the stick.

7. Take the fabric and wrap it tightly around the paper.

8. Take the pipe cleaner and wrap it tightly round the fabric, twisting once, and leaving the ends out.

You have now made a doll! (The pipe cleaner is the arms. Sometimes the patients twist it too tightly.) People are surprised and intrigued. Then bring out all the glitter and fun stuff and ask them to decorate their doll and make it their own. Everyone likes to do this and there is often laughter and deep concentration. Using a big glob of glue stick glue dug out by a stick works well to affix everything. (Other glues take too long to dry.)

We then ask them to name the doll, share the worry or wish *if they want to*, and tell us, or the group, what the doll wants. The names are often fanciful, the worries or wishes are often poignant, and what the doll wants is often the

solution to the worry. For example, a social worker may feel overworked and wish for more time, fun, etc. They may make wild dancer dolls with feathers and glitter that wish to go dancing—a good release from their stressful workload.

Finally we ask them to put the doll by their bed (stuck on a bit of clay or Model Magic) or take it home and put it on their desks or in their cars. Whenever they think about the worry or wish they may ask their doll to hold it for them. Since these wishes or worries are often beyond their control, this might relieve them by giving them more space to focus on something they can actually change. People have often held onto the dolls for a long time and fed back that the experience was fun and moving. At the same time you learn a lot about a patient without probing or asking directly.

Pointers

Do not promise a child, especially the little ones who still believe in magic, that their wish will come true. Introduce the doll as a helper who will hold the worries so that they have to worry less. Do not provide children under three years with any materials so small that they could be swallowed.

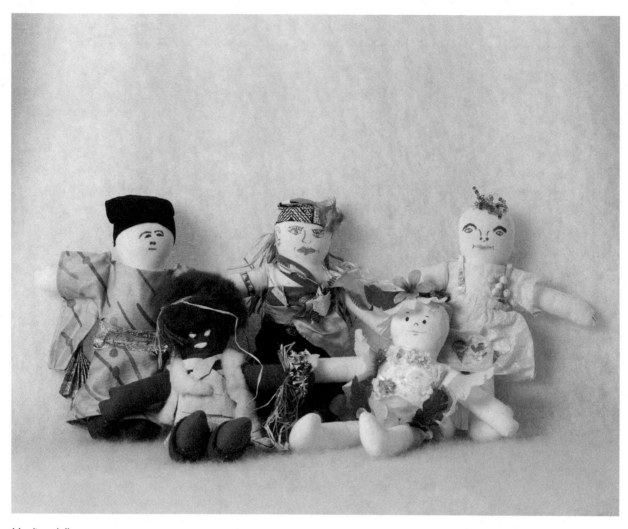

Healing dolls

Second doll from left: Barbara Skelly

I am making the doll for the health of the world. Sumi faces the challenges and fights back. She gathers the healing moss and shells, concocting the healing brew. She is looking inside for answers.

Fourth from left: Wende Heath

I am making this doll for myself and all people who seek healing. As Spring and its beautiful flowers surely arrive after cold wet winters may hope and healing and good health arrive to all those who need it after their dark and cold experiences with serious illness.

Fifth doll from left: Carol Durham

Cancer

It's painful
It stinks
It's terrifying
It's life changing
I conquered I'm alive
I love life
T H A N K Y O U G O D

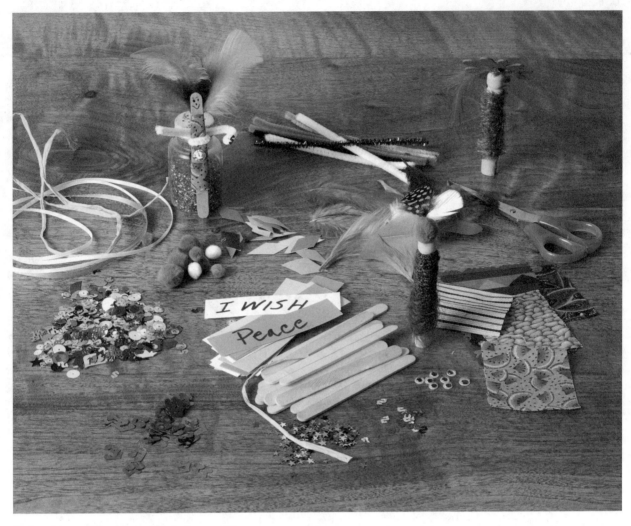

Doll-making: wish or worry dolls (see page 63)
Wish or worry dolls and ephemera:
Popsicle stick doll: anon.
Clothes pin dolls: Matea Pfeifer

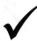

Drawing or painting to music

👤👤👤 Group
👤 Individuals
🔄 Bedside
1+ All ages

Materials

• Paper

• Paints and brushes, or colorful drawing materials

Begin by laying out all the materials beforehand. Then, after a relaxing meditation, put on the music. Begin with a very quiet volume setting and slowly bring the volume up as you feel necessary. When the patient is ready, he/she can begin painting. Feel free to play the music selection as many times as the patient wants, but be careful to stop the music at the end of the selection.

Pointers

If the patient has finished and the music has not, just turn down the volume, but try to allow the selection to finish. Each composition has its own structure and built-in "closure." Stopping abruptly without allowing a selection to finish detracts from the effectiveness of the musical experience. Be sure to see Live and recorded music (p.78) as well as Facilitated drawing or painting to music (p.68) for musical selections as well as additional pointers.

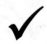

Facilitated drawing or painting to music

♦ ♦ ♦ Group
♦ Individuals
⤴ Bedside
1+ All ages
☑ Can be made for the patient

Materials

- CD player

- Variety of music from classical and slow to cowboy and hard rock

- Paper and paint

If the patient is unable to paint on their own due to their reduced energy levels or physical handicap, the facilitator carries out the artwork under the direction of the patient as to form, color, etc. Have about 20 minutes of music available. A selection can be played through just once or repeated. It is important to stop the music at the end of the selection because pieces have closure built into their structure. It is better to follow the inherent structure rather than stop abruptly, which might be too jarring for the artists at work.

Pointers

Pay attention to the volume and be sure that the music does not disturb room-mates when working with individuals. Different types of music bring about different responses and it is hard to know exactly which type of music will elicit a particular response. Everyone has favorite songs or songs that remind them of some special time or place. A safe choice is always Mozart in a major key. The music has fairly predictable resolutions and the pieces are generally long enough for a patient to finish a piece. Try to stick with instrumental choices as lyrics might be too direct an influence on the patient's artwork. Selections by Handel and Vivaldi are generally good too. Many people have memories associated with the Beatles and feel comfortable with their music, especially the more lyrical pieces. For something well known, like Beatles songs, the content of the lyrics may play less of a role than an unfamiliar selection, because the patient does not necessarily have to spend time listening intently to hear the content as it has already become part of their musical landscape. A general rule of thumb is that a major key with ascending lines tends to elicit happiness and a minor key with descending lines tends to elicit sadness and other unhappy emotions—but this is only a general rule. Remember, too, that cultural differences are important to consider, and different cultures have different musical structures that may bring up certain emotions. Remember, if neither you nor the patient is comfortable with where the music is taking them, you are always free to choose a different selection.

Stay away from anything too energetic if you are at the bedside, because rest is an important part of a patient's recuperation.

Patients often bring their own music to the hospital to play on a Walkman, Ipod or other portable device. Their own music might be a good place to start, because there is always a reason behind their preferences. Music connects them to other times and places and that can bring a great deal of comfort. If they want to talk about the music with you, you can guide them by helping them consider the major elements of music—harmony, melody and rhythm—as well as any associations they may have with the piece, such as where they first heard it, or what it means for them.

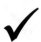

This is also a particularly good activity for adolescents, because their social world revolves around belonging. They are busy finding their place in society, first in the group and then in the world. Music is one of the easiest ways for a teen to feel part of a group: "We all listen to heavy metal," for example. Given the ease of new file-sharing technology, they create and share play lists with one another. Sharing and listening to music is bonding as well as a form of communication. No longer do they have to wait for the radio to "play our song;" they can dial it into their Ipod with the sweep of a finger and share it with a new acquaintance.

Favorite season

♦ ♦ ♦ Group
♦ Individuals
↪ Bedside
1+ All ages, including seniors
☑ Can be made for the patient

Materials

- Paper
- Markers
- Oil pastels
- Crayons
- Scissors
- Colored construction paper
- Tissue
- Glue or paste

This is a dialogue between patient and facilitator; it can lead to art-making or not. Ask the patient to choose a time of day and season of the year that especially appeals to them. Help them to engage all of their sense memory to awaken their experience. What do they see and feel? Taste? Touch? Hear? What are the colors, weather, shapes? Are there associated memories? This can lead into icebreaking conversation or suggest an art activity such as drawing, collage or coloring.

Variations

Create a cut-out collage. They can focus on colors, shapes and forms by cutting out colored paper. Just make sure the patient has enough manual dexterity. Young children can draw the shapes first before they cut them out, whereas older patients may benefit from the freedom of allowing the shape to arise, rather than having to follow a specific line. When the French artist, Henri Matisse, was bed-bound toward the end of his life, he developed cut-out collages, and today they are still some of the most beloved artworks in the world. It might be helpful to have a book of Matisse collages to share with patients. This way, patients can see how effective even the simplest cut-outs can be.

Image cards

♦ ♦ ♦ Group
♦ Individuals
↪ Bedside
1+ All ages

Materials

- Picture postcards or index cards with evocative images from magazines glued onto the cards. (These cards are made by you *before* the session—it is a good idea always to have a stack of these cards ready on the art cart.)

Image cards can be used for those who might find it hard to jump straight into an art activity. It is an easy way to engage patients in conversation and find out a bit about them. Make it a game:

1. Have the patient choose one card that represents him/her right now. Ask them to talk about it. Why were they attracted to the card? This gives you immediate insight into the patient's world. For example, "I chose this card because the man in the picture looks frustrated; that's how I feel right now," or "I chose this card because it reminds me of the farm I grew up on in Minnesota." Right there you have the beginning of an informative narrative about the patient's childhood.

2. If you have more time, have the patient choose three cards. After they have chosen the cards, ask them to choose one for past, for the present and for the future and then ask them to tell you about the cards.

3. Allow them to choose several cards they like and then free associate with them. For example, a card with an image of a farm might make them respond with "apple," or "red schoolhouse," or "farmer." The facilitator can write down the words. The patient's words can be used to create poems, too. These can be read back to them exactly as they were spoken and written down by the patient. It is as if they composed an imagist style poem while engaged in the creative process.

Pointers

Sometimes the person falls in love with a card. If they are index cards, you can give the card to the patient and they can use it for the start of a picture or collage, or just hang it next to their bed to bring color to the otherwise neutral setting of the hospital room.

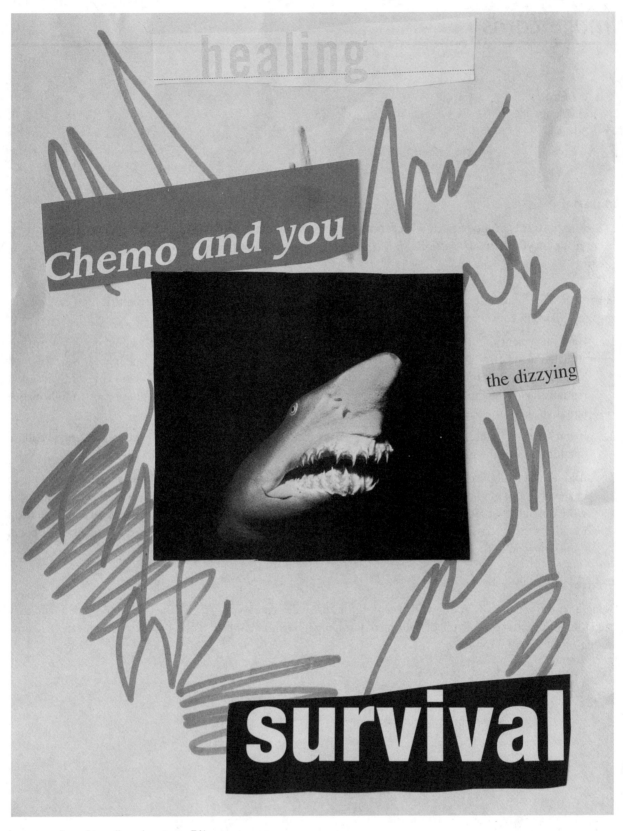

Image card used in collage (see page 71)

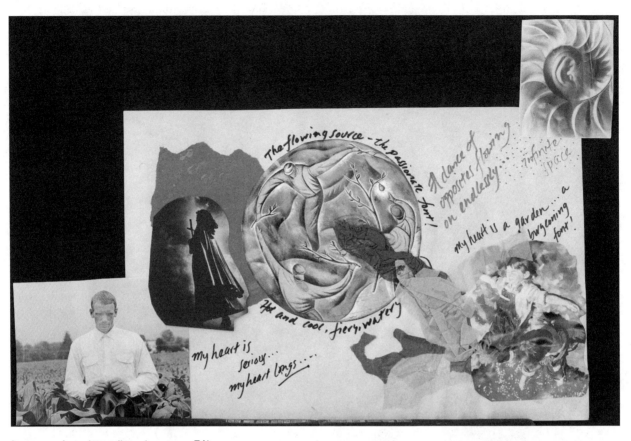

Image card used in collage (see page 71)

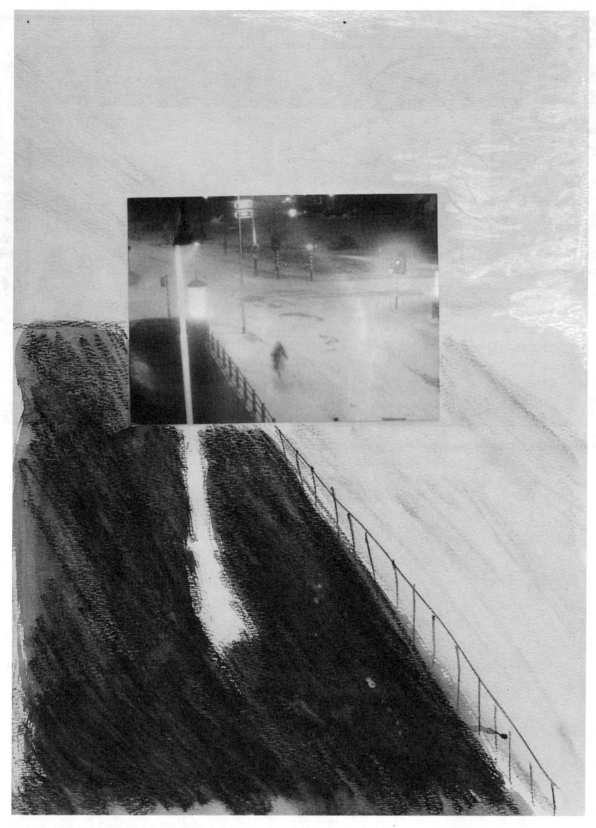

Image card used in drawing (see page 71)

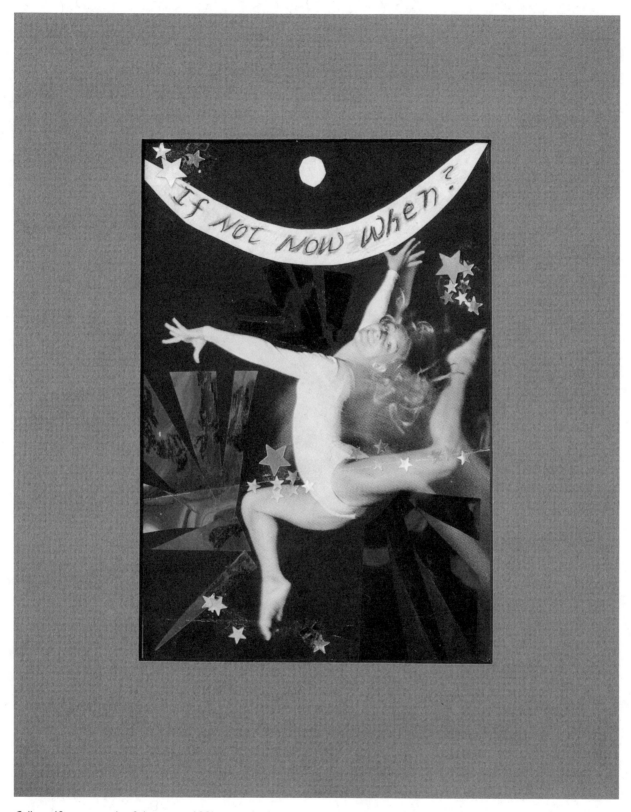

Collage: If not now, when? (see page 123)

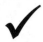

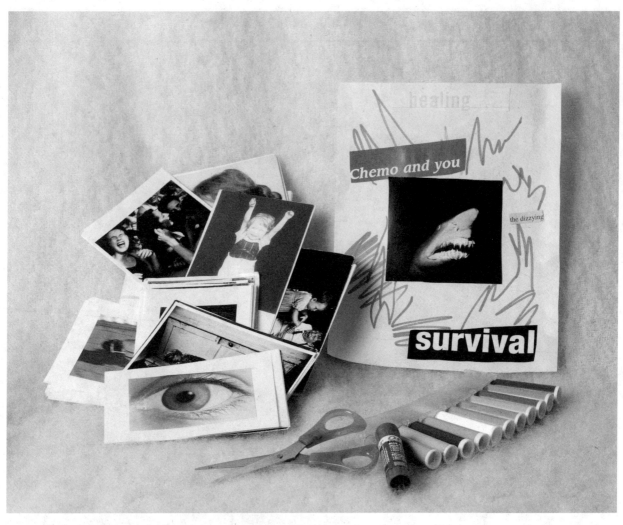

Image cards (see page 71)

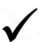

Intro ideas

♦ ♦ ♦ Group
♦ Individuals
↩ Bedside
▮1+ All ages

Materials

- This is a dialogue activity to get to know your patient(s). It can stand alone as an activity or lead to a simple art project. For the first session with a group or patient, the goal is to get to know each other, to create a safe space, to learn names, and for the patients to reveal a little information about themselves in a non-threatening way. Ask them, "Is there a story behind the name you were given?," "Do you have a nickname?"

Variations

1. Many imaginative questions can be used in group settings. Here are a few suggestions:

 - Whom do you admire? Why?

 - What are you proud of?

 - What do you wish someone would say about you?

 - If you had three wishes, what would they be?

 - If your mood were a color, what color would it be?

 - If you were to receive an award what would it be? What would it be for?

 - If you could tell the world anything what would it be?

 - If this were a costume party what would you be wearing?

2. If you are working with a group, divide everyone up with a partner. Interview your partner as to name, occupation, what they are most proud of, or any other information that would be applicable to your group and appropriate for the age. Name, pet and favorite color are easy questions for young children. Then have each person introduce their partner to the group as their "new best friend."

3. This can lead to a simple art project such as making a name card for the table, if it is a group activity, or draw a picture of your favorite pet, for groups or individuals, etc.

4. Ask the group to seat themselves alphabetically by name, or to change their seats. Sometimes just rearranging the group and their favorite seats can lend a new perspective to the group.

Live and recorded music

† † † Group
† Individuals
↩ Bedside
1+ All ages

Materials

- CD player
- Variety of CDs (See Facilitated drawing or painting to music, p.68, for musical suggestions.)

Live music is wonderful in the hospital. It helps reduce stress and can be very effective in pain management. Much has been written about music therapy. See Appendix D, p.207, for further reading.

Many hospitals feature piano players, guitarists, recorder players (a recorder is a wooden flute-like instrument) and harpists who play by strolling from room to room. If you play an instrument, bring it into the art activities.

Recorded music is also always a nice addition to art-making. It can help set a mood or mask unpleasant, distracting sounds from the environment.

Pointers

Be aware of the volume level and whether the music might bother room-mates. Not everyone shares the same taste in music, and Bach or heavy metal might really irritate someone. What is pleasant for you or your patient might have an uncomfortable association for someone else. They might have been forced to play that Bach prelude thousands of times by a merciless, decrepit, crotchety old music teacher—you never know. Music is a very personal internal experience. You can always close your eyes to an image that does not appeal to you, but we do not have ear lids.

Manic, jumpy, nursery music does not belong in pediatrics in spite of how fun it might be at home. Rest and relaxation is important in the hospital. It takes energy to recover. Lullabies and comforting songs with simple predictable melodies or repetitive rhythmic structures that mimic the human heartbeat are soothing for little patients. For a child who may have to be separated from their mother or father, a recording of their parent's voice or a recording of them singing a lullaby can be enormously supportive. A relative can bring a tape recorder from home and make the recording right in the hospital, too.

Magic Paper

♦ ♦ ♦ Group, including family members or friends
♦ Individuals
↩ Bedside
[1+] All ages

Materials

- Good quality Japanese or Chinese brush

- Magic Paper is available where art paper is sold, is a product designed to test brushstrokes, and several different companies manufacture it. The paper may be displayed on a board or behind matting. A ready to use version may be purchased commercially under the name of "Zen Board" at www.zengifts.com

- Water

Magic Paper is a useful approach with a shy and reluctant artist and never fails. Dip the brush in water and give it to the patient. Ask them to make some marks on the paper. Because of the shape of the brush, the marks are aesthetically pleasing and because of the special nature of the paper, they disappear in a minute or two when the water evaporates! People are fascinated by the evocative and fugitive images. Magic Paper allows even the sickest or most timid of patients to paint, and often encourages them to continue on with real paint. The images can be a jumping off point for conversation.

Variations

1. Patients who are a little more adventurous can hold the brush with their toes and make a few marks. They then see that it is about process and not control.

2. The patient might find words for the images that arise and these can be translated into a haiku poem. The form for a haiku contains only three lines and it adds up to 17 syllables. The first line has five syllables, the second line has seven, and the third has five.

Pointers

Magic Paper is the easiest, quickest and least threatening activity there is. Even if you have only five minutes it is enough time to do a Magic Paper activity. The facilitator can also make a mark on the board first and show a patient how it is done, confident that it will not leave a mark when the patient is ready to begin. The fact that the marks evaporate takes away any fear the artist might have about a finished piece. This allows them to focus on the process. Magic Paper is one of the most basic supplies one should have and no art cart should be without it.

Mirror image

⚹ Individuals
↩ Bedside
1+ All ages

Materials

- Paper
- Markers
- Crayons

Draw a line down the center of a large piece of paper or fold it down the middle. Allow the patient to draw abstractly on one side of the line while you mirror the image exactly on the other. Then switch round. This is a simple drawing that brings the facilitator and patient together in an harmonious activity.

Variations

Once the patient is comfortable, the game can become even trickier. Try loops, and even crossing the midline of the page.

Pointers

Go slowly, as mirroring can be quite difficult if the movements are too fast or chaotic. For the first drawing, we suggest that the patient draws a continuous line without lifting the pen off the paper. It can waver or wiggle in any direction from the top of the paper to the bottom.

Prayer bead bracelets

�\dagger �\dagger �\dagger Group, including family members or friends
�\dagger Individuals
↩ Bedside
6+ Age 6 and upwards
☑ Can be made for the patient

Materials

• A variety of beads

• Stiff wire

• Fastening fittings

• Elastic cord

The intention of this project is to be present and in the moment with a prayerful, meditative attitude. Strings of prayer beads (or "wish" beads, if the patient is not favorably inclined toward religion) are used in many of the world's major religions as objects of reflection and prayer. Large beads can be used for specific prayers or intentions, with smaller beads as spacers. The bracelets can then be worn by the patients, or given to the patient by a family member. They can be worn after the hospital stay as reminders of health-giving behaviors or prayers toward healing. This activity can also be accompanied by breathing exercises, music or reading aloud.

Variations

With a group of friends or family make a prayer bead circle—the hospital version of a "sewing bee." Bring in extra chairs and arrange everyone in a circle that includes the patient. This is an especially nice activity to share with a patient and their visitors. A simple activity like making bracelets can help give focus to a visit. It might also encourage visitors to stay longer, because awkward moments of silence in a conversation can be construed as "time to leave," when actually the patient may just want to share their comforting presence but is having difficulty keeping up with the conversation because of breathing difficulties, low energy level or lapses in concentration. If everyone is busy with a project in their hands, silence is completely acceptable, and the mood of quiet industry can itself be a healing experience.

Pointers

Do not use beads with children under three years. Children under eight years of age can make plain bracelets with very large beads. Beads with larger holes are easier to string for both seniors and young children, and of course the facilitator can make the bracelet under the patient's direction. Prayer bead bracelets can be used with anyone who understands the concept.

Reading aloud

- ♦ Individuals
- ☞ Bedside
- **I+** All ages
- ☑ Can be done for the patient

Materials

- Books of fiction, poetry or any story appropriate for the age of the patient

Reading appropriate material aloud such as poems and short stories allows the patient to be receptive and relaxed. It may invite conversation or artwork. We also read aloud to very sick patients who may want company but are unable to participate because of fatigue. We are going to highlight some books that work well in this setting.

Kitchen Table Wisdom by Rachel Naomi Remen MD (see p.207 for full details) is a good choice. Please be familiar with the contents of the extract before you read to be sure that the selection is appropriate for your patient as some are deeply moving and do not shy away from stories about patients with life-threatening or terminal illnesses. This book is a treasure trove.

The Gift of the Magi by O. Henry (see p.208 for full details) is a short story available in many collections. It is a charming story about sacrificing what is dearest for love.

Women Who Run With The Wolves by Clarissa Pinkola Estes PhD (see p.208 for full details) is full of wonderful stories of empowerment for women, and there is an especially lovely re-telling of the Hans Christian Anderson fairy tale about the Christmas Tree, where even after being stripped of holiday decorations and chopped up, the Christmas tree still provides warmth.

The Man Who Planted Trees by Jean Giono is a longer story that can be read over a few visits. It tells how a man brought whole square miles of land back to health after the devastation of war by planting one tree at a time. Children 11 and older will like this story as well.

There are beautiful poems by Walt Whitman, William Carlos Williams and William Butler Yeats among others.

Children of all ages always love *The Complete Tales of Winnie the Pooh* by A.A. Milne (see p.209 for full details). Just one chapter, or a chapter per visit, will delight the little ones, or nostalgic older children too.

Contrary to what one may think, Grimm's fairy tales are not for the faint of heart. They can be quite dark, as the evil is always rewarded by an equally or more beastly punishment! The children do not seem to mind, but some adults may be mortified. The Mrs. Piggle-Wiggle books by McDonald and Knight are fun as each chapter is a new story of how the inventive Mrs. Piggle-Wiggle solves a problem, and each story has a moral (see p.208 for full details). For example, she cures not sharing by putting so many locks on the child's belongings that the child cannot remember the combinations or which key goes to which toy. Another time she teaches a child to wash by planting carrot seeds on his dirty face.

Poems are very popular too: A.A. Milne's *Now We are Six* and *When We were Very Young* and Robert Louis Stevenson's *A Child's Garden of Verses*.

The Secret Garden by F.H. Burnett is another childhood classic that can be read over many sessions, by different visitors. It is an uplifting story about a girl's curiosity and fortitude that leads to a new and healthy life for her cousin.

Lastly, any animal poems by Ogden Nash bring a smile to both young and old. See "Books to read aloud" on p.208 for more information about all these books.

Variations

Any story or poem is a great jumping off point for art. Making illustrations for favorite stories is an engaging activity for children and even for some adults.

Pointers

It is easy to get involved with the story yourself while reading it. Make sure that the patient is not too tired to keep going and, if they fall asleep, quietly leave the room. It is easy to leave a little note to say you would be happy to come back and finish the story another time—"sweet dreams."

Rorschach paintings

♦ ♦ ♦ Group
♦ Individuals
↪ Bedside
1+ All ages

Materials

- Paper without a polished coating that will absorb the paint
- Tempera paint
- Brushes
- Water for clean up

Fold the paper in half and then open it up flat. Dab liberal amounts of paint on one half of the paper. Fold it back in half again along the crease, making sure that the painted side contacts the unpainted side. See what happens. This is a no-fail project and sometimes the pictures are quite beautiful. Spend time with the patient talking about the piece. Are any images or thoughts revealed? Is it surprising?

Variations

The patient can add to the print. Certain features can be brought out or added to. In this case the print is just a starting point for creativity. Often patients see butterflies with symmetrical wings…

Pointers

This can be a messy project, so make sure it is easy for the patient to clean their hands afterwards. A warm, soapy washcloth brought to the bedside is always a nice gesture. Little children might be intrigued by the squishiness of the paint as the two sides are pressed together. You may want to press it for them as they might be tempted to begin finger painting. Finger painting can be quite regressive and we would never recommend it for children in the hospital setting.

Stickers

♦ ♦ ♦ Group
♦ Individuals
↩ Bedside
1+ All ages

Materials

- Stickers of all kinds—they are manufactured by a number of companies, some of which will donate seconds to pediatric wards

- Paper, white or colored

Children love stickers. Seniors love stickers. Everyone loves stickers. They are simple and kids can make pictures or stories with them. If there is a message on the sticker, they can be offered or stuck on the hand or chest of adults. That usually causes a smile. If you think a patient may not want to be touched by a member of the opposite sex (because of cultural differences), you can always offer them a sticker and they can put it wherever they would like. We started giving them to nurses every week and you would be surprised how such a little gift was appreciated. It generates smiles for both the receiver and all the people who pass by in the halls.

Media-based Activities

Sometimes, simply presenting an art technique without theme or directive will elicit the most wonderful work. This is especially true when the art technique is new to the patient. The opportunity to use beautiful, high quality paints, or try something unusual, can be very exciting. It can certainly brighten up any hospital stay. Here, the process is the most important thing. How does the paint feel under the brush? How do the colors blend? It is not about a finished piece at all. The patient is being given the time and opportunity simply to explore.

Bookmaking techniques

† † † Group, including family members or friends
† Individuals
↩ Bedside
[1+] All ages
☑ Can be made for the patient

Materials

- Paper for the pages

- Card stock paper for the covers

- Collage pictures

- Markers or pens with fine points

- Raffia, or ribbon, string for binding

- Stapler or hole punch

- Scissors

- Glue sticks

Making books has proven very popular in the authors' experience. It is new to most patients and the most charming book can be made with the simplest of materials. The book can be used for a card, for a poem, or a special message. Although we always emphasize process over product, because we are primarily interested in the efficacy of artistic expression, and personal interaction, we often make books in order to create a product.

Patients who need a "pick me up" and a reminder that they are more than just someone who is sick and not very capable, treasure the opportunity and their own ability to create something that is not only beautiful but also looks professional. They are usually surprised at the result. They can show it off or give it away.

Books can be very simple or quite elaborate. The internet is a great resource for different techniques and sometimes the simplest change can create extraordinary results. You can use any kind of paper, from recycled pulp or clean waste-paper scraps to fancy wrapping paper or end papers printed especially for book-making. The front and back covers are best made from a heavier paper or card stock that can be handled repeatedly. You can obtain this paper for free by asking for the end cuts from your local printer. The covers are cut a bit bigger than the pages. We have not included any dimensions because you can make big or tiny books depending on what you want and the paper you have.

Book one

Materials

- Two to four pieces of paper, folded in half and placed on top of each other (the leaves)
- One piece of colored paper, cut slightly bigger, folded in half and placed on the bottom (the cover)
- Ribbon
- Stapler

Bind the book by stapling the layers together at the top and again at the bottom of the center fold.

Variations

Using the same set-up and materials, punch holes through the entire folded book, top and bottom (or more often if the book is very large). Thread raffia or ribbon through the holes. You can probably figure out two or three ways to thread the ribbon (in and out, bows, knots, etc.). Be creative. As long as it holds together, it is fine.

You can use one page for each line of poetry–a cinquain (see p.92) needs at least six leaves, a haiku (see p.92) needs three—or put it in the middle of the book across the gutter. Feel free to glue collage pictures to the other pages or draw with markers or watercolor, but make sure that the paper will hold up to water colors or glue.

Book two: accordion book

Materials

- Long narrow piece of paper (ends from the printer or legal paper)
- Two pieces of card stock or cardboard, ¼" larger than the width and length of the folded paper
- Raffia or ribbon

Fold the long strip of paper back and forth evenly, so that each page is the size you want. You can glue lengths of paper together to make the accordion longer if you want more pages. A cover should be glued to each end of the accordion book and a ribbon long enough to wrap around the book and close it should be glued in at the same time between the last page and the back cover. Make sure the ribbon extends out from the front edge of the book. Tie the ribbon around the accordion and tie in front or wrap it up like a little package.

You can use the accordion book for poems such as the cinquain, a story, or pictures. The pages can also be collaged. Books are a beginning that says "fill my pages" please, but empty books also make lovely gifts on their own. Be sure to refer to the next section: Poetry.

Poetry

† † † Group, including family members or friends

† Individuals

⤶ Bedside

1+ All ages

Books are a wonderful canvas for the patient's poetry, but poetry can also be used alone or as a multi-modal adjunct to an activity. For example, a patient might work with Image cards (see p.71) and through word association with each image, craft a stream of consciousness, free verse, poem. It does not matter whether material fits an established poetic form or not, because what arises carries significant meaning for the author. However, there are several poetic forms that are relatively quick, easy and very effective. These include the cinquain, the haiku, the limerick and the triolet.

Cinquain

The traditional cinquain is based on a syllable count. We, however, use a form based on a word count that relates to groups of nouns, adjectives and verbs. Here is our recipe for a cinquain:

Line 1—one noun tells what the poem is about (subject and title)

Line 2—two adjectives describe the subject

Line 3—three gerunds (verb forms that end in "ing" such as hopping, laughing) describe something the subject does or an action related to the subject

Line 4—a four to six-word-long descriptive phrase or sentence describes a feeling or the subject further. This is a good place for similes and metaphors

Line 5—one or two words rename the poem (a synonym) or give it a punch

Here are two examples:

Tree
Green, majestic
Living, shading, breathing
It grows so tall!
Sequoia!

Beagle
Joyful, happy
Leaping, jumping, fetching
My running partner and friend
Go Boy!

As you can see they are simple but evocative. You and the patient can start with a sample, making up a poem on the spot together. Use what is happening in the present, in the hospital room or office. Do as many together as necessary for the patient to get the idea and then help her make her own. Here is an example:

Surgery
Scary, necessary
Opening, closing, curing

I pray for good results.
Of course!

The haiku

This is a Japanese form that usually takes nature as the subject matter. The traditional form is very simple, unrhymed and just three lines and seventeen syllables long. The first line has five syllables, the second seven, and the third five again. The content focuses on nature. Because of the brevity of the form and its traditional association with nature the haiku tends to evoke images of the natural world, that may, or may not, have potent emotional affect. Here are two examples:

> Street lamp flickering
> Black dog barking at the light
> Two p.m, echo.

> Bold, buckeye chestnuts
> A child's game of conkers
> Bruising silly boys

The triolet

The triolet is a medieval form that is very effective because of the use of repetition. It is eight lines long, with an Abaaabab rhyme pattern. The first line is repeated for the fourth and seventh lines. The second line is repeated for the eighth line.

Although the triolet is often equated with light or humorous concepts, it is also effective for emotionally charged material. If a patient comes up with one strong idea, the poem is almost written. Here are two examples by a teenager, struggling with her peer group:

> Gossip is treacherous
> Like rapture of the deep
> It beckons us
> Gossip is treacherous
> Partisan and mutinous
> Through every crack it will seep
> Gossip is treacherous
> Like rapture of the deep

> Red is the color of vengeance
> A game of Achilles fury
> A language spoken through violence
> Red is the color of vengeance
> Nipping at the heels of offence
> Glancing blows, light feet dance as they hurry
> Red is the color of vengeance
> A game of Achilles fury.

The limerick

This is the most commonly known poetic form and the content is always humorous and often bawdy. We have yet to hear a serious limerick! Limericks will certainly lighten the mood in any situation. The limerick has five lines and the rhyme scheme is Aabba. The dominant meter is anapestic (weak beat followed by a strong beat), but a few unaccented beats can be slipped in without too much harm: wSwwSwwS. An example is: There *was* an old *La*dy from

Fife… It is made up of two feet in the third and fourth lines, three feet in the others (a poetic foot is a group of weak and strong beats, in this case weak-strong. Here are two examples, the first from the same teen who wrote the triolets and the next a well known example from Edward Lear's *Book of Nonsense* (2005):

My doctor prescribed counting sheep
As I was unable to sleep
A "dream" butcher came running, his cleaver was stunning
The sheep ended up in a heap.

There was an old man with a beard
Who said, "It is just as I feared!—two owls and a hen, four larks and a
wren—have all built their nests in my beard!"

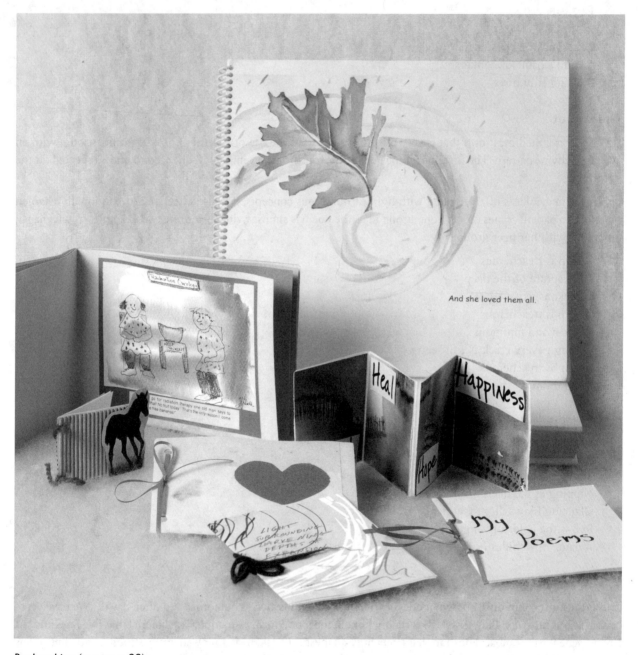

Bookmaking (see page 88)

Printing techniques

ȧ ȧ ȧ Group, including family members or friends
ȧ Individuals
↵ Bedside
I+ All ages

Printing onto paper is an easy and fun technique to use with patients. It is experimental, does not always require drawing skills, and with a variety of colored inks or paints and lots of interesting stamping material, even the novice artist can produce something exciting. Most patients have not experienced this technique (except possibly vegetable printing with cut potatoes and similar projects) and so they have not built up prejudice against this medium. Just experimenting with colorful materials is therapeutic, and the activity can be as long or short as the patient's attention span or energy level permits. We suggest mono-printing techniques in which each print is singular and individual.

Although some techniques require more manual dexterity, purchased rubber stamps with interesting images or words and colorful ink pads are easily manipulated, and the results can be very interesting. Rubber stamps can also be used in many of the other theme-based activities and are an excellent icebreaker too.

Mono-printing

† † † Group, including family members or friends
† Individuals
↶ Bedside
1+ All ages

Materials

- Paper. Use paper that is absorbent, such as construction paper, newspaper or rice paper

- Ink or paint. Water-based inks (such as the ones manufactured by Speedball) are best, but acrylic and tempera paints are also good. (They just dry very quickly and will gum up your stamps if not cleaned off quickly)

- Brayer or brushes. A brayer (a small roller with a handle) or brush are needed to spread the ink

- Shapes to print. Use any cut-up vegetable, wooden shapes, stamps, textured fabrics, pieces of cardboard or anything you can think of that would work to make a print. Half the fun is inventing new stamps

There are two simple ways to print. Either you can dab some ink on the stamp and, using a paint brush or a brayer, spread the surface of the stamp with a thin layer of ink and then print on the paper, or alternatively you can dip the object onto a paper plate with some paint on it and then print. Do not use too much ink or paint because the delicate lines and textures of the stamp might be lost. The brayer will give you the most even and thinnest application of paint.

Styrofoam printing

ŧ ŧ ŧ Group, including family members or friends
ŧ Individuals
↪ Bedside
I+ All ages

Materials

- Paper, same as above

- Ink or paint, same as above (gold and silver are nice choices to have in your palette)

- Brayer or brush

- Styrofoam pieces—either purchase Styrofoam at the art supply store or recycle the Styrofoam sheets from the grocery store that are used to package meat or vegetables. Just be sure to wash and dry them thoroughly.

- Pencil, nail, or skewer

- Flat wooden spoon

Make a drawing on a piece of Styrofoam by etching into the material with a dull pencil. Using a brayer in the same manner as above, ink the drawing. You can also squeeze some acrylic paint directly onto the Styrofoam.

Lay a clean sheet of paper (white or any color) on top of the Styrofoam and press with your hand or the back of a wooden spoon until the paper has picked up the image. Pull off and set aside to dry. The Styrofoam can be used multiple times.

Pointers

Be sure not to use too much ink, especially if the drawing is delicate, because the indentations will fill up with ink and the image will not transfer. Remember, too, that if the patient wants to include words in their piece, it must be written as a mirror image, because it will print in reverse.

Tissue paper and white glue

♦ ♦ ♦ Group, including family members or friends
♦ Individuals
↩ Bedside
1+ All ages

Materials

- Colored tissue paper
- White paper for backing
- White glue (preferably Elmer's) diluted with water three to one
- Brush to apply the glue

Tissue paper and white glue is a tried and true technique that is lively, easy and almost always produces a product that is satisfying. If you can tear paper and use a paint brush you can do this technique. The paper sometimes bleeds and combines with other papers to make lovely colors and interesting shapes. The surprise element keeps it playful and surprising.

With a brush, apply watered-down glue to a piece of backing paper. (It will eventually be completely covered by tissue paper.) Tear pieces of tissue paper and lay on the glued paper. Paint glue over the previously glued tissue and keep layering until the picture is done, ending with a final coat of watered glue. Wash the brush every once in a while as it might begin to pick up too much color from the artwork and also carry bleeding color from the tissue into the glue pot.

Watercolor techniques

† † † Group
† Individuals
↢ Bedside
12+ Age 12 and upwards

Most people are familiar with watercolors. However, they usually remember cheap, student-grade watercolors with cheap brushes that fell apart and left hairs on the page. Or they remember how the paint mixed with every other color paint in the tray and turned a yucky brown, and they often remember that it was hard to learn.

When you present watercolor for the first time, it should be a whole new, wonderful, creative experience. If the patient already knows how to use watercolors, or is interested in learning, free painting is always a good way to go.

Materials

- Watercolors. Have pan sets available rather than tubes of color. This is more compact and easier for groups to manage. Good quality sets are manufactured by several companies, including Prang, Caran d'Ache, Grumbacher, Pelikan, and Windsor and Newton

- Watercolor Pencils. There are several brands available. They look like ordinary colored pencils but they dissolve in water and can be used for a variety of techniques

- Watercolor crayons. They work like crayons but, like the watercolor pencils, also dissolve in water. Caran d'Ache and Neocolor II watercolor crayons are heavily pigmented and easy to use

- Brushes. They need not be expensive, but do not buy the tiny, inexpensive ones that fall apart. Providing a variety of sizes is important. A small detail brush and a 3/8" and 5/8" flat brush should do, and a generous sized Chinese brush is also nice. A brush that holds a point is a nice addition to your cache of supplies, but is only worth the expense if you can take proper care of it—time to dry, safe storage, etc.

- Paper. High quality paper is essential, not a luxury. Ninety pound (130 gsm) paper and above, hot and cold press paper, heavy enough to stand up under the liberal use of water, makes a tremendous difference to the entire experience of making art

- Water

- Clean sponge

- Table salt

Wet-on-wet method

Place the paper on a waterproof surface, such as a Formica table. Wet the paper with a large, clean sponge or large brush. Be careful to smooth out any bubbles with the sponge that might form underneath the paper before adding paint. Load a brush with wet paint and apply it to the wet paper. The paint will bleed over the wet surface. Drip and blob paint around the surface of the paper. Colors will blend on the paper: reds and blues will turn purple, yellow and blue will turn green. It is a good idea to limit the palette at first to just blues, reds and yellows, so that the patients can have the experience of new colors arising on the page. Beware of using too many colors, to avoid the picture turning gray. You can add watercolor pencil or crayon, and if the page is not too wet these materials can give more control and detail to the image. The result is usually more beautiful than the patient could have imagined, as all the colors mix and drip together in unexpected ways.

Pointers

As your patients become more familiar with the feeling of the wet-on-wet method, they can become more adventurous and try painting referential images, but this needs more understanding of the medium than beginners might have. Remember, the less water on the page, the more control one has. Wet-on-wet, by its very nature, discourages control and highlights the surprise element. For some patients this is liberating; for others who might be struggling with how to control their illness, their life, etc. it can be an enlightening experience, or just completely frustrating. To avoid frustration, introduce the medium as a way to play and to awaken curiosity, or introduce the watercolor pencils as a way to make a more "deliberate" mark on the page.

Watercolor pencil and crayon

The watercolor pencil and crayon can be used dry, on dry paper, and water can be added later. To use this technique apply color or try dipping the pencils or crayons into water and then applying them to the paper. Pencil and crayon will mix with the water and look just like regular watercolor, but they tend to carry more pigment than a brush load of paint (unless it is quite dry). It is a way to get a bit more control of the image for those who do not yet have watercolor technique, but it still has the feeling and presence of the watery element.

Watercolor flooded into wet brushstrokes

Using a brush with clean water, draw shapes, or make letters, on the paper. Then carefully drop watercolor paint into the watery shapes. The pigment will fill the shapes with color.

Pointers

Make sure that the shapes have not dried out before adding the pigment, and if they are too wet they will sit there as pale puddles and dry unevenly.

Watercolor and salt

Paint a free-form design with watercolors. Sprinkle salt in some sections and it will draw the watercolor toward it, creating an interesting grainy texture and design.

Pointers

This is another way to add a surprise element to the work. It is also a lesson in non-attachment as the patient has to be comfortable with the idea that their work will continue to evolve. I suggest explaining the technique at the very beginning, rather than mentioning it just before adding the salt.

Theme-based Activities

These theme-based activities generally require 30 minutes or more to complete and have an "agenda." One might tap into images of the Self, or pain, for example. They are appropriate for a second art-making visit or for those patients who are familiar with the expressive arts and are ready for a deeper experience. Most of the activities work well with groups and especially with seniors.

Many of these exercises rely on active imagination or guided imagery (explained on p.101). Often this starts with a brief relaxation period in which you ask the patient to close their eyes, take some deep breaths and let go of the day. Sometimes we do a "body scan," working our way up and down the body, asking the patient to clench and relax all the major muscle groups so they are in a relaxed, receptive mood when the instructions for the project begin.

Relaxation

In our theme-based activities we often begin with a relaxation exercise. This is meant to quiet down the patient or group, who may have just arrived from their busy lives in and outside of the hospital. It helps them focus on the present moment and it also heightens their receptivity to the guided imagery, poem, or directives of the activity. Keep it short for seniors or after a meal, or you might put them to sleep!

There are many ways to encourage relaxation. Dimming the lights is helpful. Speaking in a calm, comforting and slightly monotonous tone helps. Most beginners err by rushing and not allowing enough time between directives for the patient to check into their body and to conjure up the images. If you are not calm, centered and relaxed when you begin, it will be much harder for the patient to reach a peaceful and relaxed place. Remember, you have to set the tone, and that may mean taking a few deep breaths or sitting quietly with your eyes closed. You might consider using music to help the group relax. There are many CDs available

designed to instill serenity. Select music suitable to the age of the group and without lyrics, slow in tempo and low in pitch.

Always give options. Although it is optimal to close one's eyes, if it makes anyone uncomfortable, then suggest that they leave their eyes open but focus softly without concentrating on a particular object. Often people breathe in a shallow manner, especially when they are anxious or experiencing pain. A simple exercise based on slow, deep breaths can take them in less than five minutes to a peaceful, relaxed place.

Instruct your patients either to sit upright in a chair or bed. You might give them a little information about why deep breathing is good (deep breaths promote oxygenation and deep exhalation gets ride of stale air and carbon dioxide). If they do not understand the concept of deep breathing, suggest they inhale as if they were smelling a bouquet of roses, and exhale as if they were blowing out candles. Generally the relaxation exercise goes as follows, but feel free to adapt it as you wish:

> If you are willing, put your feet flat on the floor and close your eyes… Focus your attention on your breath… Breathe in, filling your abdomen, bringing in health-giving oxygen… Breathe out and let go of the tension of the day and all the toxins your body no longer needs. (*Model this by breathing in and out about three or four times more loudly than you would normally, so that they can hear the breath.*) Feel the tension released from your body with each exhalation.

At this point, if you have more time, you can begin a full body relaxation by guiding them to relax starting with their heads and moving to their feet. If your time is short, you can stop here and begin with the imagery part of the exercise.

> Pay attention to your face. Really tighten all the muscles while inhaling…hold for a moment, and then let the tension go as you exhale. Notice the little muscles around your eyes… Now move your focus down to your shoulders. Lift and tighten them… Hold… Then relax, feeling the tension drain out with each exhalation… (*Do the same with all the other major muscle groups.*) Tighten your hands and arms…stomach…buttocks…legs… and feet…

They are now ready to receive the guided imagery part of the exercise, if there is one, or they are ready to begin with their art project. If you want more elaborate scripts for relaxation, you may find them in Lusk (1992, pp.1–33).

Guided imagery

This part of the exercise sounds very professional, but the goal is simply to encourage people to imagine, use their mind's eye and engage all their senses: sight, touch, taste, smell, hearing and kinesthetic (the sense of movement). Often people say that they cannot imagine or see things. Ask them how many windows there are in the first floor of their house. They will go from room to room in their imagination, counting the windows and usually having no trouble correctly numbering the windows. This is guided imagery. The exercises are intended to elicit images that can be expressed through art, either on paper, in clay or through movement and sound. One example might be:

Imagine your childhood bedroom. As you walk through the door take in all the details. How big is it? What color are the walls? What does your bedspread look like? Does it have a special smell? What do you hear from your bedroom? When you are ready come slowly back and be ready to draw what you just saw.

In this case they are searching their memory for a real image like the windows. Keeping it in the present tense underlies the fact that the memory can be activated as a present reality. Another example might guide them to imagine something new, but it might be based on scenes they have experienced in their lifetime:

See yourself on a warm beach in some location where you feel safe and happy. Hear the waves, feel the sand, smell the air, and see the landscape and vegetation. When you are ready come slowly back into the room and draw what you just experienced.

Another example is completely new and not based on the past. It is, of course, based on familiar concepts, but it is not as self-explanatory as a landscape. A typical subject when working with ill people is to imagine an "inner advisor":

In a clearing you see your inner advisor. This is someone with deep wisdom who always has your best interest at heart. Is it a man or woman? What is he/she wearing? Does he/she say anything to you? What do you know about him/her?

When they formulate an image (it can be almost anyone, such as a religious figure or someone with great wisdom and dignity) you can then direct them to ask any number of questions about decision-making, healing, etc. This is where information about the patient can come in handy.

Another example might be a cancer patient who is asked to imagine his/her cancer cells as an image and then to imagine what is needed to destroy them. The art process then takes over; the patient might draw the cancer cells being overcome. Experience has shown us that people have great wisdom that is sometimes inaccessible to their logical mind. However, when given the opportunity to access that unconscious information through symbols, imagery and the art process, the knowledge is easily revealed. Guided imagery is one easy method to bring images to consciousness and, as we have seen, giving these images concrete form through the artistic process allows these images to continue speaking to the patient.

We must always respect the images that arise from these exercises, even if they seem odd, or even weird, to us. It is important to refrain from commenting and let the explanation unfold on the patient's own terms. The patient's unconscious holds more knowledge about them than the practitioner will ever have. Images arise as complete concepts and even if they do not make sense now, and are not immediately understood, they do hold knowledge about the patient. It must also be remembered that logical understanding is only a fraction of the health-giving benefit of art-making. It happens to be the way we are used to seeing the world. Understanding is comfortable. The act of releasing this information into the conscious realm is healing in itself and does not need to be understood to be efficacious. Images can make sense, be weird or be very impressionistic. The patient may not recognize their experience as an image. For example: "I didn't see anything, just colors and vague shapes. I have no idea what they are about." We always keep in mind the wise words of Pat Allen (1995, p.60):

Remember that the image is the messenger of your soul and never comes to harm you. The misperception of the art school critique is that the image needs to be improved through criticism. The misperception of art therapy is that the image must be analyzed. Both approaches try to overpower the image with intellect. The image needs to be known, seen fully with loving attention and encouraged to speak, treated as you would treat an ambassador from a different world. Then it will develop and reveal itself according to its own logic.

Abandoned object

† † † Group
† Individuals
⮌ Bedside
50+ Seniors

Materials

- Paints and brushes, or
- Markers
- Paper

Begin with a relaxation exercise with eyes closed if the patient is willing. When they are relaxed and with eyes still closed give the following instructions:

> Imagine being out on an evening stroll in the city, and you pass a deserted store. As you walk by the window, you see an abandoned object in the window. Try to imagine the history of the object which captures your attention.

Allow plenty of time for the patient to ponder the object, then ask them to paint a picture of the object and write about it.

Pointers

This exercise is designed to tell you something about the person through the use of imagination and metaphor. Many seniors feel abandoned and they suffer many losses as they age. An example of an abandoned object might be an old trumpet. The story might be of the music it made, who played it, and why it was abandoned. It is often helpful to have patients tell the story as if they are the object. "I am an abandoned trumpet. I was born in St. Louis at the turn of the century. I was bought by a milkman who had a small band he played with on weekends…" You are always listening for the similarity between the story or metaphor and the person. In this way you can ask questions and begin dialogue, always staying in the metaphor. "What was St. Louis like in the turn of the century. What was it like being played by a milkman and not a professional musician?"

Body as nature

† † † Group
† Individuals
⤸ Bedside
18+ Age 18 and upwards

Materials

• Paint

• Watercolors

• Oil pastels

• Large sheets of paper

Begin with a short relaxation, then create your own guided imagery about living on a planet of seas and vapors, mud, fire and dust. Our blood and hormones are fundamentally sea water and volcanic ash; our skin shares its chemistry with the maple leaf and the moth wing. Ask them to depict themselves as part of nature.

This exercise requires some sophistication, but ultimately it can be a discussion about belonging. We are part of the earth and part of nature. If we feel isolated, it is simply because we have forgotten that essentially we do belong. Modern life can be disconnecting: we no longer make our clothes and grow our own food. Remembering that we are part of the earth's ecosystem, that even our cells are made up of the same materials as the forest, for example, can be of great comfort, especially for seniors who may feel isolated. This is a reminder that we are all in this together. Feel free to initiate a dialogue with simple questions: What does if feel like to know you are mostly water…share most of the DNA of a gorilla, a snail? How does it feel to be part of nature?

Body-based imagery

👤👤👤 Group
👤 Individuals
↩ Bedside
12+ Age 12 and upwards

Materials

- Paint
- Markers
- Oil pastels
- Large paper

Begin with a relaxation exercise and then ask the patient(s) to keep their eyes closed, if they are willing, while you give them this suggestion:

> Bring your attention to any area of your body that calls out to you. If none does, choose an area of the body you would like to get to know better. Focus on that part of the body and notice what color it is, its texture, shape and form, both inside and out. Ask it what it needs. Imagine this in color, shape and form. When you have an image, open your eyes and draw what came to you.

This can be followed by questions and discussion: "What was that like for you? Could you imagine your body part? Did it have a need? What was the need and how did you imagine it?" The intention is for the exercise to lead to some self-awareness, nurturance and healing.

Pointers

This is a good exercise to do if the patient is experiencing pain but is still comfortable enough to do art. Sometimes by focusing on the pain and getting to know it better, the experience of pain diminishes.

It is helpful to have the paper and drawing materials readily available so that the patient can immediately begin working while the images are fresh in their mind, rather than spend time getting out what he or she needs.

Body-mapping; head, heart, hands, feet, whole body

ↂ ↂ ↂ Group
ↂ Individuals
↪ Bedside
16+ Age 16 and upwards, including seniors

Materials

• Paper

• Collage images

• Scissors

• Glue sticks

This is a project to be done over a number of sessions. Each session, a different part of the body is addressed. Begin with the head in the first session and then move down the body in order, the feet being last. Lead into the project with a relaxing meditation that ends with a focus on the body part you are working with that session. In the final session begin with an overview of the entire body.

Ask the patients to visualize the physical, emotional, mental and spiritual layers of the body part. Ask the following questions: "How does the head (or hands, feet, etc.) connect us to the world? Is the head sensate? Does the head think? Does the head feel emotions, imagine, create or hold memories? How does the head present itself to the world?"

As a different part of the body is addressed in each session, ask the patient to write down their thoughts on a piece of paper. Then ask the patients to choose a limited number of collage materials, either illustrative or photographic, for their body part. (The head is best represented by one image, the hands and the feet by two—because the experience of right and left are different—and the heart by one or more because that gives the patient the chance to express how the heart feels at different times and toward different people.)

When they are ready they can take a fresh piece of paper, draw an outline of the head, for example, and then paste the "head" image they have selected onto their drawing. This should happen for each body part. During the last session they should take one very large piece of paper and connect the outlines and images, forming an entire body of all the different images. They may want to write on their "form" as well, adding ideas from their writings. Please stress that it is not meant to be a realistic portrait of the person at all, but a reflection of their inner life. Leave lots of time for sharing thoughts and feelings.

Pointers

Each body part has certain qualities. The head, heart, hands and feet are mentioned above, but one could also focus on the stomach, or the breasts, for example, and tailor the choice of body parts to the individual or group with whom you are working. The heart is a good choice because we generally consider it to be our emotional core, the head our thinking organ, and hands and feet because they take us places and do things for us, but other parts of the body may be very significant for certain patients. Be sure to consider both the physiological and emotional qualities of each organ. Many things, expected and unexpected, may arise during this exercise. The body tends to carry memories that may not be conscious all of the time. Tenderness in a hand may have an organic or even an emotional basis. Be supportive of the individual's experience and if someone is not comfortable opening up in the group they should feel free to pass and you should move on to the next person.

Body-mapping: Hands (see page 108)

Body-mapping: Whole body (see page 108)

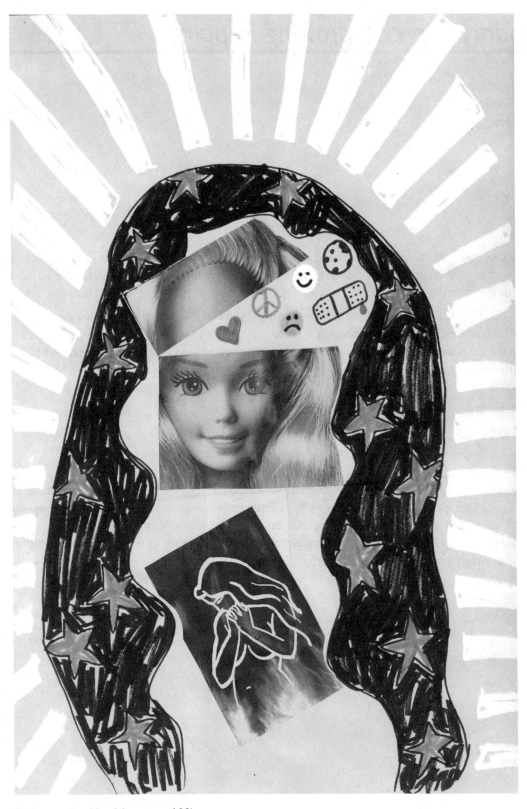

Body-mapping: Head (see page 108)

Boundary exercise: drawing in pairs

♦ ♦ ♦ Group
1+ All ages

Materials

- Large paper
- Markers

Divide the group into pairs. Each couple shares a single sheet of paper. Guide one of the individuals to begin. The idea is for each person to concentrate on their partner. Direct them to draw together in silence for 30 minutes, either abstractly or concretely.

This is a good exercise for adolescents, couples and seniors who feel powerless. Ask the two people in each pair to speak with each other about the experience. Ask them to note any feelings that arise regarding boundaries, styles and imagery. What did it feel like to have your partner change your picture, go over your lines, etc.? What do you know about your partner from the experience?

Variations

The entire group works on one large piece of paper simultaneously.

Pointers

This is a powerful exercise to do with adolescents and seniors, but I suggest only drawing for ten minutes. Children may draw in pairs with a parent. As children mature, parents need to let go and allow their children to express themselves. With a sick child a parent may feel the need to be more controlling. Very soon after starting they might feel that they are in conflict. Keep your eyes open and switch to dialogue as soon as you see frustration build. Talk a bit and resume drawing, if you feel it will be beneficial.

Boxes

 ♦ ♦ ♦ Group, including family members or friends

 ♦ Individuals

 ↩ Bedside

 10+ Age 10 and upwards, including seniors, family members and friends

 ☑ Can be made for the patient

Materials

- Paper

- Scissors

- Glue

- Pencils

- Ruler

- Magazine pages cut into squares or origami paper

These boxes are lots of fun and stand as an activity on their own or can be combined with other expressive arts activities. They are based on a Japanese origami design. We suggest that you make one yourself before trying it with a patient.

Cut two sheets of paper into exact squares, one 1/4" larger than the other. The larger sheet will be the box top and the smaller sheet will be the box bottom. Use a 6 3/4" square for the box bottom and a 7" square for the box top. The finished box will be 2 1/2" wide and 1 1/4" high. You can make your box any size you wish. The directions for folding the box top and bottom are the same, so follow these directions to make your top and then repeat the directions for the bottom:

1. Using a ruler, lightly draw an X on the wrong side of a square piece of paper from corner to corner. If you have chosen a particular magazine image make sure you are marking lightly on the opposite side of the image you wish to use (see Figure 1).

2. Still with the wrong side facing you, fold one corner down to the center of the X (see Figure 2).

3. Keeping that corner still folded to the middle, fold the same section again to the center line. In other words, the edge created by the first fold should be folded down to meet the center line (see Figure 3).

4. Open up both folds so that the paper is flat again and repeat both folds with each of the other three corners (see Figure 4).

5. There are now fold lines on either side of the X pencil marking. Make two cuts into the sheet of paper along those lines as far in as the center four little squares which are delineated by folds. Turn the paper 180 degrees and make two cuts the same way on the opposite side of the paper (see Figure 5).

6. Fold in the sides that are shaped like big triangles by bringing the points (which are corners of the original sheet) to meet at the center point of the pencil X. Then bring the folded edge of the same triangle up to form the sides of the box. Do the same on the opposite side. The edges of the box are now in line with the four cuts (see Figures 6 and 7).

7. Bend the sloping corners of the big triangles in to create the other two sides of the box (see Figure 8).

8. Tuck the strips with cuts on either side over the folded sloping edges. Their points will meet in the center. These strips will finish the box and a dab of glue will help secure it in place (see Figure 9).

9. Repeat the folding instructions for the second square of paper. Decorate the top and sides of your box if desired (see Figure 10).

10. Then instruct the patient to write down three things on separate small strips of paper: something they love, something they want to get rid of, and something they are in the process of changing. Place the papers inside the box and share with the group.

Variations

For patients who have difficulty with manual dexterity, or who may have difficulty following directions, collect small purpose-built boxes instead, and let them decorate the boxes with collage pictures. It is extremely helpful to fold one at the same time as your patient. Often they find it easier to follow visual rather than verbal cues.

Pointers

This is a good exercise for groups, or even a new patient, as it can both build trust and elicit support from the group. Sharing what you love with someone requires trust, because what you love is often a tender secret. One of us (Suzanne) loves the rain for example. It sounds simple, but the idea of it is much more complex than the statement may appear. The idea could have deep associations or symbolic meaning. Sharing what the patient wants to get rid of means that they have already made a decision to let something go, and by stating it in the group the participant has made public an intention to do so and is initiating the action right then and there. It can be as simple as "I want to get rid of my old suit." Or "I want to get rid of the habit of chewing my nails." Stating what one wants to change takes courage because it is generally something in process and, by stating it, one is asking for group support. What one wants to get rid of may be concrete: "I want to get rid of my car." What one wants to change may be complex: "I want to change my relationship with my husband."

Trust the participants or the individual to do the editing. They know what they are ready to say. By keeping all the options open they can be as self-disclosing as they need be. The difficulty in a group is that some may be more self-disclosing than others. Start with someone who is likely to be more reluctant to state the really difficult, or highly personal, ideas and allow those who are more comfortable with self-disclosure to go last. That way there is no pressure on them to be more self-disclosing than they would like to be because they are setting the precedent for the level of disclosure with which they are comfortable.

Figure 1

Figure 2

THE EXPRESSIVE ARTS ACTIVITY BOOK

Figure 3

Figure 4

Figure 5

Figure 6

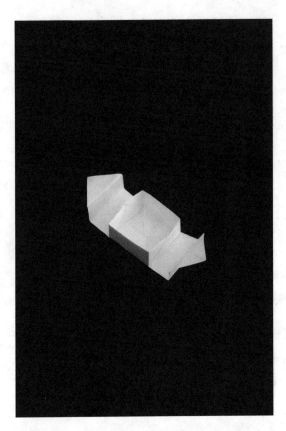

Figure 7

Figure 8

Figure 9

Figure 10

Build a city

� � � Group
� Individuals
↩ Bedside
50+ Seniors

Materials

- A sheet of paper large enough to cover a table
- Collage images
- Glue sticks
- Scissors
- Colored pencils
- Markers or paint (optional)

Make a group mural with collage pictures and drawing and painting. The theme is to build a city, including all the things a city needs to be successful. Lots of things will arise while the mural is underway so be sure to leave plenty of time at the end for the group to discuss the evolution of their metropolis.

A subsequent session could explore what it would be like to be a person living in this city. What sex would you be? What kind of work or activities would you do there? What is the best thing about this city for you? Are there any dangers in the city for you? Is there anything you would need to add to the city? Favorite restaurants? Parks? Museums? How far away does your best friend live? Who lives next door?

Pointers

In story-telling or staying with the metaphor, people often reveal a lot about themselves. A question such as "What kind of city would you like?" may actually be asking what they might be missing in their own city. Isolation is often an issue for patients. So questions about community and support systems might reveal areas that can be addressed therapeutically or even taken up with family members or social workers when the patient is discharged.

Childhood

Ť Ť Ť Group

Ť Individuals

↪ Bedside

25+ Age 25 and upwards, including seniors

Materials

- Paper
- Markers, or
- Crayons

Think of yourself at age 12. Try to remember how you felt when you were young. What was life like at the time? Think of what you did and what was fun for you. Depict this memory through images. This activity often leads to story-telling, which is especially appropriate for seniors. They particularly enjoy re-living past happy experiences, especially if the future is uncertain.

Variations

1. For patients who need more concrete suggestions you can ask them to imagine their childhood bedroom.

2. Ask people to narrate their pictures. This can be a starting point to open up the conversation.

Collaborative body scan

♦ Individuals
↩ Bedside
1+ All ages

Materials

- Paper
- Markers
- Oil pastels

This exercise is good to use with people who are physically ill and need some understanding and the possibility of relief from pain and suffering. Through guided imagery or dialogue, help the patient locate the pain or discomfort. Have them describe their pain and then offer them art materials with which to give it physical presence. Ask them to give it color, shape and movement. Mention the qualities of texture and intensity. How can they achieve these with the art materials? You might ask them to rate the intensity of the pain by measuring it on a scale from one to ten. Then you can look at the drawing together to see if it reflects the intensity. Specific questions can be very helpful in guiding them towards an understanding of their experience, such as, "What is the color? Is there just one color? How intense is the color? What is the shape of the pain?"

The images may appear as a whirl of scribbles and colors. Sometimes there are referential images. It is the action of making the art that is the point here. Let them know that sensations and emotions, such as tension, fear, apprehension or frustration, can be expressed through the action of making art. This is an exercise where they can communicate with themselves.

Variations

A second part of the exercise might be to imagine what is needed to help lessen the pain and/or cure the symptom. For example, if the painful image is a monster with sharp claws, the help might be a way of disabling the monster. This can also be expressed in colors. For example: red jagged lines might represent pain and watery blues might be the answer for lessening the pain.

The information can then be elaborated on in an additional session, by using guided imagery focused on the helper (practitioner, carer or friend) and making more specific pictures.

Pointers

Keeping the metaphor alive and the story going is a different way to approach illness for most people. By the time they get to the hospital they have already told the story of their illness over and over again to doctors, nurses, interns and therapists. Through art they often they come up with very helpful insights into their pain or symptoms. Be clear that this is not about a finished piece; this exercise is about process.

You can leave behind crayons and paper at the end of the session and, if the exercise helped reduce pain, the patient can return to paper and crayons whenever they need.

Collage book series

♦ ♦ ♦ Group
♦ Individuals
I+ All ages

Materials

- Variety of magazines with good pictures, or already cut-out images
- Sample of poetry books with themes pertinent to the group
- Folder to store images and writing examples
- Bookmaking materials (see Bookmaking techniques, p.89)

This is a long project that benefits from several sessions or even one or two "workshop" days that might include two long sessions. Pick a specific theme that will direct the activity but still leave enough latitude for individual expression. Typical themes include: "Nature changes," "Faces of children," "Health" or "Stages of recovery."

Over a number of weeks direct the patient(s) to collect pictures and writing that illustrate the theme. These should be stored in a folder. When they have collected a body of work, assemble the pictures and writing into any style of handmade book (see Bookmaking techniques, p.89).

Pointers

This is a good project if your group requests "homework" to enhance what happens in the group sessions. Bringing in special treasure the patients have collected is a nice way to get conversation rolling, especially for reluctant participants. Most importantly, it keeps the connection to the group active between sessions. It might even be good to assign the task of adding one image or piece of writing a day in the space between sessions. For the person who has never journaled, this gives them time to focus and experiment outside of the group. For those who may be distracted by a magazine's content while they thumb through for images, I would suggest offering cut-out pages or individual images before the sessions meet. They can then narrow the choice further without being distracted.

Collage images that move you

♦ ♦ ♦ Group
♦ Individuals
⤺ Bedside
1+ All ages

Materials

- A selection of images
- White paper
- Scissors
- Glue sticks

Present a stack of images. Allow the patient to sort through and choose several images that have impact for them. When they have collected a pile of pictures, look through them together to see if there is a theme. Arrange them on white paper and see what develops. They can be glued in place or not.

Variations

This activity leads nicely into story-telling and poetry. As the patient discovers the theme and how the pictures connect to one another, take notes. These can be used as the basis for writing. This is also a good technique to learn about the patient in a non-intrusive way.

Day and night mandala

Material

- Two large circular pieces of paper with the same dimension: at least 36" in diameter (butcher paper is a good, inexpensive choice)
- Felt-tip pens
- Collage pictures
- Glue sticks

Cut out two large circles of paper. Then cut one piece into as many equal pie slices as there are participants in the group. Each person is given a triangle of paper and asked to depict something related to either day or night. When they have finished, allow the group to arrange the pieces on top of the second circular piece of paper, glue them in place and hang the finished collage on the wall.

Desert island

♦ ♦ ♦ Group
6+ Age 6 and upwards

Materials

- Piece of butcher paper large enough to cover the entire table
- Felt-tip pens

Before the group meets prepare "the island." On the paper draw a large island with some inlets. Leave enough space around the island for the water that surrounds it. Ask everyone to imagine that they are going to a desert island and will not be able to leave. They need to bring everything that they will need to live on this island. Pass out markers and ask them to draw on the island what they will need.

Pointers

This is a very interesting project that can give you quick insights into the individuals as well as the group. What do they think is important in their lives? Some are very practical and bring tools. Some bring their families, sometimes forgetting someone. Teenagers usually include coke machines, music and places to dance and hang out. Some people draw boats so they can escape from the island. Sometimes there are lively discussions around sharing items when group members see someone drawing an item they would also like to bring. How do they divide up the space? Do they intrude on others? Do they build fences? Who is isolated? Who wants to live in a village? Do they share resources, such as a river? Does cooperation live in the group, or are the participants more individually motivated?

This activity inevitably leads to a lively discussion. Make sure that you take notes as the island grows. The process is just as important as the final map. Your notes can help facilitate the conversation; for example, "How did it feel when John placed his vegetable garden right in front of your house?" "Why does Samantha want to be on top of the mountain?" Remember, they are being met at the level of survival, yet imagination can supply every need. This is a good metaphor for those who may be struggling with life-threatening diagnoses.

Design a CD cover

♦ ♦ ♦ Group
♦ Individuals
↩ Bedside
14+ Age 14 and upwards

Materials

- Card stock
- Markers
- Collage pictures

Cut heavy card stock twice the size of CD covers with a fold in the middle so the cover can open and close. Instruct your patients as follows. For the front cover, imagine that you are a famous singer or in a group. Invent your stage name, if you want one, and the songs that you would write and sing that say something about you. Imagine what you would look like. Using collage pictures and markers design the covers. For example, a picture of a wild and beautiful woman that implies Super Woman would suggest she sings songs of triumph: "I beat it back," "Watch her, Doctor, she's hot." Inside the cover, list all the songs and a short imaginative biography that can be glued in as an insert.

Pointers

The CD format might be unfamiliar to some seniors, or too small for their failing eyesight. Try making a "retro" LP cover instead.

Dialogue balloons

✝ ✝ ✝ Group
✝ Individuals
↬ Bedside
I+ All ages

Materials

- Pictures of people
- Paper
- Glue sticks
- Markers

Instruct your patient(s) to choose four to six images of people and to glue the pictures to the paper, making sure to leave room for comic strip "dialogue balloons." Leading questions might be "Are they family members? Strangers? Friends? Where are they?"

Create an improvisation in your mind. What would they say to one another if they met at a party? At home? On the phone? Imagine what each person is thinking or saying. You can use the markers to record their words.

Pointers

This exercise is a visual drama. The interactions depicted may be harsh, or scary, or comforting and loving. The activity can be adopted to play out specific scenarios, but the intention is that it should always be patient-led. Offering a wide variety of pictures of individuals doing specific tasks, and demonstrating ethnic, cultural and economic diversity, are important. By limiting the images beforehand, the facilitator can more specifically direct the scenario.

Dreams and aspirations

♦ ♦ ♦ Group
♦ Individuals
↪ Bedside
15+ Age 15 and upwards, including seniors

Materials

- Writing paper
- Drawing paper
- Either paint and brushes, or
- Felt-tip pens, or
- Colored pencils
- Pen

Lead a relaxing guided imagery that enables the patient to consider his/her dreams and aspirations during young adulthood and adolescence. The patient can either begin with journaling or with paint and brushes.

Variations

This activity can be easily adapted for young children. Begin with a discussion of what they want to be when they grow up. This can become quite lively, especially when they tell you why they want to be a nurse, garbage man or astronaut!

Pointers

The goal is to reawaken the excitement of planning a future and jumping into the realm of possibility. Even though the outcome may be different than was imagined, and the patient may feel regret or disappointment, there is still a spark of possibility alive in these memories.

Dream strip

♦ ♦ ♦ Group
♦ Individuals
↵ Bedside
14+ Ages 14 and upwards

Materials

- Paper
- Paint and brushes, or
- Markers

Fold paper into four sections. Ask the patient to think of a dream that was important to them. They can give it a new ending if they wish. In each of the four sections, they should depict one scene from the dream.

Pointers

This is an opportunity for the patient to relate unconscious material that may be very revealing for them. As they create, keep a simple dialogue flowing. While in process they may begin to make sense of the dream, or if the import is already clear, they will have the chance to galvanize the inner meaning in a concrete form. This can be very supportive for them, especially if they feel the dream is highly significant.

Emulate an artist

♦ ♦ ♦ Group
♦ Individuals
↪ Bedside
16+ Age 16 and upwards

Materials

- A selection of books on different artists
- Paper
- Colored pencils
- Felt-tip pens

Bring in a selection of work by artists in different styles, such as Van Gogh, Andy Warhol and Michelangelo. Point out how each artist used color and form and ask them to do a piece that is reminiscent of this way of working. You might ask, "Does the landscape you want to draw feel like a Turner, or a Breughel?" The big question, of course, is "Why?," but that may not become clear till the patient begins to work. The style chosen is tied up with the emotional climate the patient wishes to express.

Variations

It might be good for the patient to think first about what subject they would like to draw and then look at that subject in the hands of a few different artists.

Endings

♦ ♦ ♦ Group
18+ Age 18 and upwards

Materials

- Plain cards with envelopes
- Stamps

At a significant closing, such as the year's end, or the last session of a group, suggest that patients make a card for themselves expressing what new thing they would like to bring into their lives and what they might like to leave behind. Have them put the card in an envelope, seal, stamp and address the envelope to themselves. Mail the card to them several weeks, or even a few months, later.

Variations

1. Each person has a card. It is then circulated to every other person in the group who writes something positive about that person. Cards are sent round the table until everyone has a card full of positive comments. Mail the cards to each patient several weeks, or even months, later.

2. Using small boxes, miniature Chinese food containers, or origami boxes (see Boxes, p.113) ask everyone to write on a slip of paper something positive for everyone in the group. Put it in the container and people can share what was written or take it home to read later.

Endings—sand painting

♦ ♦ ♦ Group
6+ Age 6 and upwards

Materials

- Colored sand (can be purchased in art and aquarium stores)
- Paper cups
- Plastic spoons
- Large table

Put each color of sand in a different paper cup. Give a cup of different color sand to each member of the group along with a spoon. (Fine sand can be mixed to create further colors, such as red and yellow to make orange or red and white to make pink.) Ask each group member to make a picture on the table with their sand, using the spoon to make lines and designs in the sand. Ask them to move around the table slowly so that each works on all parts of the picture.

When this has been done everyone admires the work. You can state that this picture is unique to this group—it has never been made before and it will never be made again. Each individual has added their own special color to the group process that enriches us all. Soon the picture will be just a memory, just as the group will be a memory. After the group leaves carrying the memory away with them, clean up the artpiece by brushing the sand into a wastepaper basket and vacuuming the floor.

Variations

Do this exercise outside in a setting where nature can erase the painting for the group and where the colored sand will not pose a hazard for anyone.

Epiphany

♦ ♦ ♦ Group
♦ Individuals
↩ Bedside
21+ Age 21 and upwards

Materials

- Paper
- Markers

We are all changed in some way by life's major events. Ask the patient(s) what event in their life precipitated an awakening. What did they know about life before this event and how did it change after this event? Draw the event or a symbol of the event.

Variations

Use fast-drying clay. Ask the patient to sculpt a symbol of the event. A symbol might be an abstract piece that defies exact explanation. Some may sculpt signs—for example, a marriage might be depicted as a wedding ring. Clay can be very playful, and sometimes the sensory stimulus of clay in the hand awakens something less conscious.

Essence of self

♦ ♦ ♦ Group
♦ Individuals
↝ Bedside
18+ Age 18 and upwards

Materials

- A variety of materials for paper or sculptural work

Using any art materials in any way you wish, illustrate yourself. What is the irreducible element without which you would cease to be the person you take yourself to be? Pay attention to whether it is big or small, light or dark, malleable or permanent. This activity can be a good jumping off point for journaling.

Expressing relief

♦ ♦ ♦ Group
♦ Individuals
↩ Bedside
1+ All ages

Materials

- Collage pictures
- Large piece of paper
- Glue sticks
- Scissors

Fold paper in half. On one side illustrate your pain, tension or anxiety. On the other side illustrate the feeling of relief from pain, tension and anxiety. This may lead to another insight: what might help to achieve relief? If there is an answer, or even a vague idea, allow the patient to draw this on the backside of the paper.

Family as color, shape and size

♦ ♦ ♦ Group
♦ Individuals
5+ Age 5 and upwards

Materials

- Large white sheet of paper
- Construction paper of various colors
- Glue sticks

Ask the patient to describe himself/herself and his/her family as an assemblage of different colors, shapes and sizes. They can tear or cut the construction paper and then arrange the pieces on the large sheet. For instance, Dad might be red, the shape of a tower and placed in the center of the page. Mom might be blue, a lacy torn shape, and placed in a corner. Ask patients to explain their choices. For very young patients, do not ask for any explanation.

Note

It might be good for them to start with themselves and see where they initially place themselves on the page and how that changes as other characters are added. Have them glue the figures in place at the end of the activity after they have created and placed every element in their composition.

Folded book

† † † Group, including family members or friends
† Individuals
8+ Age 8 and upwards

Materials

- Paper

- At least six color markers, or

- At least six colored pencils

On one side of a large piece of paper, quickly draw an abstract image with up to three colors. Be careful to extend the image out to the edges of the paper. With three different colors do the same on the backside of the paper. Fold the paper in half (top edge meets bottom edge) and fold a second time, this time bringing the right edge to meet the left edge. Holding the spine of the book in your left hand, slit with scissors the top (or bottom) edges of the pages that are still connected. Punch two small holes on the left side so that the pages can open like a book and string a ribbon or yarn up through the holes and tie them off. Then, working spontaneously, begin to write down words in free association to the abstract image on each page. These musings are poems that can then be read aloud.

Friends in my life

♦ ♦ ♦ Group
♦ Individuals
↵ Bedside
I+ All ages, including seniors

Materials

- Paper
- Drawing materials

After a relaxing guided imagery, allow the patient to focus on a family member, friend, acquaintance or pet that has been important in his/her life.

Variations

Pets are fun to create in fast-drying clay. It is helpful to have some pictures of animals at hand to give patients an idea about proportions. It is interesting to see that even though someone might have cuddled their cat every day, they might not have taken note of their pet's actual shape.

Pointers

This, like most activities that depend on old memories or reminiscences, is a good choice for seniors.

Giving

† † † Group

7+ Age 7 and upwards, including seniors

Materials

- Paper
- Drawing materials

Share a story or poem about giving with the group. For a longer story we are very fond of O. Henry's short story, "The Gift of the Magi," but it may be too long and tiring for some patients to hear the story and then make an art piece. Have the patients make a card expressing what they would like to give, to whom, and possibly why.

Variations

1. If the group members are very familiar with each other, they can break into pairs and make specific "gifts" for one another. Or everyone can put their name on a piece of paper and these can be passed out at random. The name one receives is the individual for whom they will be making a "giving" card. Just make sure that no one is left out. You can include yourself, or not.

2. Each member can make an origami box (see Boxes, p.113) and put the name of the present they would like to give inside the box. Then all the boxes can be given to another group member and opened either at the same time in the group or one at a time. The "gifts" can be read aloud and shared with the whole group.

The habitat project

↟ ↟ ↟ Group
7+ Age 7 and upwards, including seniors

Materials

- One large piece of paper, big enough to cover the entire table or work area

- Drawing materials

- Simple percussion instruments, such as drums, tambourines and triangles

Lead the patients in creating a series of connected habitats. Each one is distinct unto itself, but must have boundaries that blend and somehow support the neighboring population. A collection of polar animals, for example, might have an ocean, or only a pond, between themselves and the neighboring Savannah wildlife. At the end of the session, have the patients create the sounds of their animal populations either vocally or with percussion instruments, both individually and all together. End with some sort of guided meditation that calms down the excitement of the session while creating a sense of connectedness between the individuals and the planet.

Variations

Each ecosystem could be made individually on a separate piece of paper. Half way through the session the participants could come together and, as a group, decide where each ecosystem should be and how they might all fit together. They could spend the remaining time creating the connecting landscapes.

Pointers

This last variation is good for a group that needs to learn how to work together well. Members may not agree, at first, where things should go, but they will find an amicable solution and see that no matter how different they are they still exist as one planet.

Halloween demons

♦ ♦ ♦ Group
♦ Individuals
↗ Bedside
1+ All ages

Materials

- Paper
- Drawing materials
- Glitter
- Fast-drying clay

At Halloween, think about fears and demons. They can be either personal or universal. Consider those whom you might be trying to overcome and those whom you enjoy embodying. These can be expressed through many different media. After the artwork is finished allow plenty of time for your patient to talk about the demon(s). Where do they live? When do they visit? Do they have any vile habits? Do they talk? If so, what kind off sound do they make, or what might they say to try and scare you? Which ones are playful? What do you enjoy most about them?

Variations

As an alternative, try oil pastel on black paper. Children might enjoy "scratch away" coloring for this project. Take a stout piece of paper and have the child color the entire surface of the paper with a rainbow of colors. There is no need for the colors to be in any particular order or form. Then color over the entire surface again, this time using a black crayon. The technique is simple. When the black crayon is scratched off the surface, the colors underneath are exposed. So the child can scratch the shape of their Halloween demon into the thick, black, crayon "night." As the scratching-away process makes little crumbs of black crayon wax, this method is less appropriate for the bedside. The idea of color and light behind the dark can be a comforting idea for children. The fear of the dark for them is the fear of the unknown. Illness and the hospital setting is definitely uncharted territory for most young patients.

Allow time at the end of the session for the demon to speak, or make a sound, or for the patient to tell a story about their demon. If the patient is ambulatory, they might also choose to move like the demon.

Pointers

Some demons are known and some are not. It may be easier for some to deal with the scary demons by making them cartoon-like or even friendly. Think of "Casper The Friendly Ghost" or Coyote, the trickster of many native American stories. Remember, sometimes we are tormented by demons and sometimes they just latch onto us and make themselves comfortable, and we are hardly even aware of them.

Historical choice

ᵗ ᵗ ᵗ Group
ᵗ Individuals
↩ Bedside
10+ Age 10 and upwards

Materials

- Journaling paper, or
- Paper and drawing materials

If you could transport yourself to any time and place, past or future, where would you go and what would you see when you arrived? This idea can be introduced in a guided imagery or not, and can move into drawings or journaling, or even simple story-telling. At the end see if the patient can tell you why this particular time period and place appealed to them.

Pointers

Older patients have a better sense of historical periods than younger children, so be sure to leave lots of room for fantasy adventures, particularly when working with children. Historical periods might also be culturally sensitive, so let patients from cultural backgrounds different from yours lead the way.

Home

┆ ┆ ┆ Group
┆ Individuals
⌐ Bedside
1+ All ages

Materials

• Paper

• Drawing materials

Guide the patient in a meditation that leads them to a home they have lived in. Let them explore those surroundings and make mental notes. When they open their eyes, they should begin to draw themselves in that environment, with as much detail as possible.

Pointers

Home is generally a comforting idea, especially for someone who is in the hospital. At home they not only have their own bed and favorite foods, but they also have their own routine that does not usually begin with a blood draw at 6 a.m. or a temperature check several times a day. Home is as much about place as it is about familiarity. This is good for patients who are on long hospital stays or for children who might want to put a picture of home on the wall.

Hospital experiences

- Individuals
- Bedside
- **1+** All ages

Materials

- Paper
- Oil pastels, or
- Felt-tip pens

For this activity, the patient draws their experience in the hospital, illustrating as much texture as possible. The piece can be referential or partly abstract, but in the latter case the patient should be able to relate the story behind the abstract section. This is a non-threatening area for discussion and a good outlet for the patient's feelings about their hospital stay.

Pointers

Some of the information that arises might be helpful for the staff and/or doctors because it might make a difference to the quality of the patient's stay in the hospital. Ask the patient first if you may share some of the ideas and thoughts that came up in the session. The thoughts might be as simple as wishing the nurses would shut the door after they had entered the room. Sometimes patients need advocates, and not only for the big decisions. Often they do not understand that they have a say in the quality of their hospital stay.

How do I feel?

♦ ♦ ♦ Group
♦ Individuals
↩ Bedside
[16+] Age 16 and upwards

Materials

- Paper
- Crayons, or
- Colored pencils, or
- Felt-tip pens

Begin with a very relaxing guided meditation. At the end instruct your patient to ask himself/herself, "How do I feel now?" When the patient is ready to open their eyes let them express in doodles and abstract shapes and images whatever came to them. The patient may decide to talk to you about what they experienced, or not. They might also choose to take one element in their image-making and explore that more fully.

I believe in myself

♦ ♦ ♦ Group
1+ All ages

Materials

- Paper
- Pens
- Envelopes
- Stamps

At the conclusion of a group it is often moving to sum up the qualities the patients have been trying to cultivate. For example, isolated seniors might be trying to become more social, or breast cancer patients might need support to believe in their own abilities and move on after treatment.

Instruct the patients to write letters to themselves which remind them of supportive memories and include words of encouragement. They then self-address an envelope and put the letter inside. Three months later, you should send these to the group members. It is often very moving for the patients to receive their own love, even months later.

Variations

Have each participant self-address an envelope. Each group member should write an anonymous note of encouragement and support on a little strip of colored paper to each member of the group. You can then place these notes in the appropriate envelopes, seal them up and send them off a few months later.

Jointed paper story dolls

♀ ♀ ♀ Group
♀ Individuals
↪ Bedside
I+ All ages

Materials

- Card stock weight paper
- Scissors
- Felt-tip pens
- Brads to attach limbs
- Hole punch
- Glue
- Ephemera

See Appendix A: Patterns and Projects (p.195) for a design that can be pre-cut, or cut out by patients. Punch holes over the dots. Line up the holes on the torso with the holes at the top of the limbs. Push the brads through the holes and fold back the metal strips. The limbs can now move freely. If the patient wants, additional holes can be punched to create knees, and elbow joints too. The dolls can then be decorated on both sides, as the patient wants.

Variations

1. The patient can write a story about their doll and, if in a group, they can read it aloud and share it with everyone.

2. Doll parts, brads and directions can be put into envelopes and made into "kits." These kits can be made at leisure by community members and then exhibited in the hospital gallery or hallway.

Pointers

Doll-making easily taps into childhood feelings. The doll, being a representation of the human form, can also be oneself, one's imagined self or a healing form of the self. One patient, a recent amputee, created dolls with missing limbs, but the dolls were employable and attractive—her imagined, healed self.

Kingdoms

♦ ♦ ♦ Group
♦ Individuals
↩ Bedside
I+ All ages

Materials

- Paper
- Drawing materials

Allow your patient to draw a complete landscape containing representatives of all the "kingdoms": mineral, plant, animal and human. It is interesting to note that the human kingdom includes all the qualities of the other three: matter from the mineral realm, growth forces from the plant realm, sensate and emotional experiences from the animal kingdom. How might color play into this theme of connection?

Pointers

This is a very easy way to engage children as this idea is familiar terrain. This is an activity that is often used diagnostically in a therapeutic setting. Note that the goal in this setting is something different from the therapeutic setting. It is about the connection between all the realms. In illness one part of our being may be demanding more from us than another. Our emotions might be running riot, or our physical balance may be off-center, or it may be a combination of all three.

Letter writing series

††† Group
† Individuals
⤵ Bedside
16+ Age 16 and upwards

Materials

- Paper
- Ballpoint pen

Begin with a relaxing guided meditation. Toward the end of the session, invite the patient to ask their "pain" to write them a letter, explaining why the pain is there, what it needs, or what it thinks your patient needs. When the meditation is over, give the patient a pen and paper and ask him or her to write this letter to themselves as their pain, explaining all of the above. If the patient is comfortable he/she may choose to read the letter aloud to you. Put the letter in an envelope and then ask the patient to write a response. The patients can put the letters away and revisit them again during another session, if they choose.

Letting go with clay

♦ ♦ ♦ Group
♦ Individuals
↩ Bedside
[1+] All ages

Materials

• Fast-drying clay

This is a very simple activity which can include a guided meditation on the theme of identifying something the patient wishes to let go of, or not. That idea can also arise out of a short conversation. Ask the patient to depict something in clay they wish to get rid of. When they are finished, you can ask them if they would like to smash the piece and symbolically, at least, let go. They may decide that they want to let go of something that is very concrete, or it might be more abstract, such as pain, or a particular feeling. It may be that they are not quite ready to destroy their work, but you should let them know that whenever they are ready they can break it, or simply throw it in the trash.

Pointers

Most children are not ready to think abstractly and you might have to help them figure out what it is they want to get rid of: a tummy ache, or sore place, or sadness. It is OK to guide them. For those who are more advanced in their critical thinking skills the field should be left wide open.

Life review books

† † † Group

† Individuals

↩ Bedside

18+ Age 18 and upwards

Materials

- Several sheets of 12" x 18" paper
- Colored pencils
- Needle and button thread

Plan to make "life review" books with important moments from your patient's life. Use one sheet of paper at a time. Fold it in half along the 12" dimension. Create a picture on the front half, and then another on the right side of the inside half. After several sheets have been finished (and this could go on over several sessions), stack on a blank sheet, which will become a cover, and then sew the top of the center fold and the bottom with simple stitches. The cover can be decorated after the book is finished. Group members can pass them around and share books.

Variations

Those who are not as comfortable drawing can make a collage and add words and titles for the pages if they want.

Light and dark mandalas

👤 👤 👤 Group
👤 Individuals
🔖 Bedside
16+ Age 16 and upwards

Materials

- Paper
- A set of lead pencils from soft to hard, or
- Black ballpoint pen
- Markers

In the guided imagery portion of the session, have the patient consider light and dark. What associations does each idea bring forth? To begin the project ask the patient to draw a large circle in the center of a piece of paper; this is the outline for a mandala. A mandala is a circular image, which is considered integrating because everything is included within the circle. Opposites are easily contained within one image. The most famous example of a light and dark mandala is the yin/yang symbol. Let your patient flow back and forth between light and dark. Offer a set of lead pencils—some soft ones and some harder ones—and show the patient how to make a gray scale from dark to light, or demonstrate how cross-hatching or a stippling technique can be used to create middle tones of gray. Or have the patient stick strictly to fully light and fully dark sections in their drawing.

Pointers

Adolescents generally tend to see the world as being black or white: "You are either for me or against me!" "You are either wrong or right." Mandalas can help them experience a different outlook where shades of gray really do exist and even black and white can coexist peacefully.

Limiting the palette

♦ ♦ ♦ Group
♦ Individuals
↪ Bedside
16+ Age 16 and upwards

Materials

- Paper
- Colored tissue and construction paper, scissors and glue for a collage-based project
- Colored pens, pencils, markers or paints and brushes
- Highlighter pens with vivid hues

Hot and cool colors can elicit strong reactions because of the focus on one extreme of the range of colors. The goal in this activity is to stay with either all warm colors (reds, oranges and yellows) or all cool colors (blues, purples and greens) and to avoid neutrals (black, white, gray, brown, beige, etc.)

The focus is not on the content of the piece but rather on the color experience. For example, it might be easy to set up a simple still life for the patient(s) with objects that are readily available, such as a glass of water and a book. The patients could also produce a totally abstract piece that is not referential in any way and which allows the colors to speak to one another on the page.

It is best for you to direct the exercise by laying out a selection of pens, pencils, markers and paints in either cool or warm colors: yellow, pink, red and orange felt-tip pens, or blues, greens and purples. The patients can then explore the subject with a wide variety of choices and explore a limited palette without feeling limited in the task.

Variations

This activity also lends itself to collage. Provide previously cut up or torn pieces of construction paper and tissue, or provide paper and scissors.

Pointers

The activity should be based on the patient's dexterity and comfort level with abstraction. Scissors are difficult for the elderly or weak to maneuver so it may be easier to provide a few torn up pieces and to encourage them to tear the shapes if they are able.

List of five

♦ ♦ ♦ Group
♦ Individuals
↵ Bedside
16+ Age 16 and upwards

Materials

- Index cards
- Pen

When one is very ill or feels depressed and discouraged, it is often hard to think of what might help. Well-meaning friends often suggest activities that are not appealing. The patient knows what they like; oftentimes they have just forgotten. Ask the patient to write on one side of the card what they really love—what always does it for them. This might be playing with their dog, drinking the perfect cappuccino, reading a book in their favorite chair where the sun comes dancing through the window. Ask them to keep this wish list of activities with them and to try to do at least one of the activities every day. And when they are feeling blue they can check the list and see which one might be of some comfort.

Variations

For people with life-threatening illness or chronic illness or depression, ask them to make a list of their dreams—what they have always wanted to do. This can be a trip to Mexico, learning to dance the tango, or writing the great American novel. There is nothing like illness to remind one that the best time to start is today. If the patient is very ill, often they cannot or will not ever be able to go to Mexico, but they can have a fiesta with tacos, mariachi music, and a video trip to Cozumel right in their hospital room. In one group a patient started piano lessons again and another gathered all her family recipes and put them in a book. This was a great legacy for her family.

Masks

♦ ♦ ♦ Group, including family members or friends
♦ Individuals
↩ Bedside
▮+ All ages, including family and friends
☑ Can be made for the patient

Materials

- Colored paper
- Scissors
- Pencil
- Colored pencils
- Markers
- Glue
- Elastic or string
- Ephemera (glitter, small cut-outs, paper ribbon, etc.)

Masks are the easiest way to try on different personas. One day the patient might feel like a monster, another day like a prince. Following the mask cut-out designs (see Appendix A: Patterns and Projects, p.193), or starting with your own design idea, create a mask that fits your fancy. While they are working on the mask the patient may choose to speak about their choices—or not. The patient is making the mask. Follow their lead. When they are finished and they have put their mask on, ask them, "Who are you?" "What do you sound like?" "How might you move, now that you are a witch, or prince or demon, etc.?"

Variations

1. Use store bought masks and allow the patient to decorate them at will.

2. For the elderly, the very young or patients too infirm to handle glue and scissors, this can easily become a facilitated activity. Often it is enough just to sit in bed and put the mask on for a minute or two.

Pointers

A longer and more substantial approach is Plaster masks (see p.166) but this is not appropriate for younger children. Providing pre-cut or store-bought masks is fun for all ages, as long as they can handle a glue bottle. Be sure to have a clear working surface and to prepare the glue bottles to make them easy to handle.

This is a very buoyant exercise. Because it encourages play and make-believe, it does take energy to stay engaged. Although fun, this may not be the best exercise for a patient with little energy to spare. Think of using this on a "good day" or in post-hospitalization settings.

This is a very festive activity for a visiting group of friends or family members, especially if they have come a long way and intend to spend most of the day at the hospital. They can make the mask for the patient while they are making their own. However, be careful that the level of activity in the room does not tax the patient. You might consider letting the family make masks in a waiting area, while the patient sleeps, for example, or is having a minor procedure.

Midpoint check-in or final session

††† Group
† Individuals
14+ Age 14 and upwards

Materials

• Current and completed artwork

• Tape

• Thumbtacks, or

• Sticky tack

The patient places all of his/her/their artwork together on a wall or table and shares their present or past experience of each piece. This is a powerful exercise, whether it is used as a midpoint check-in in a group of sessions or at the end of a series of sessions. Patients have often forgotten their earlier work, and they gain insight into themselves and their journey of self-discovery when they have the opportunity to view the entire body of their work.

Questions to ask may include: "What is the difference in seeing the body of artwork as one assemblage?" "Are there underlying themes, shapes, colors?" In a group, if the patient is then willing, the other participants may wish to comment on the images and how they speak to them personally, using "I" sentences: "If it were my artwork, I…" The presentation concludes with the patient's title of the collection.

Pointers

Commenting on others' work requires sensitivity. This is always appropriate for individuals but it can be tricky in a group. Think carefully about doing this with a group of teens, although it is very appropriate for individuals 14 and upwards. But do not be fooled, age does not necessarily mean maturity. Even "mature" adults have to be taught how to respond. Learning to use "I" statements can take some practice and it is good to take plenty of time at the beginning of the session, or even the session before, to practise with the group.

Mood drawing series

✝ ✝ ✝ Group
✝ Individuals
↩ Bedside
I+ All ages

Materials

- Paper

- Glue

- Colored pens and pencils

- Ephemera (little printed cut-outs, small photo clippings, bits of metallic paper, paper ribbon, etc.)

Using art materials express how you would look if you were a color, a season, an animal, a time of day or an historical figure.

Variations

In a group setting this is a good check-in exercise, because it can be very quick. Patients can write the name of the color or time of day on their name card and that can be part of their greeting to the group. Seniors and children like the continuity of beginning with this exercise at the opening of each group.

Pointers

Moods are constantly changing and sometimes as fleeting as the time of day. This can be a quick introductory exercise or a longer project, depending on the situation.

For a quick introduction try the time of day or a color. The activity can be as simple as holding up a selection of colored paper or an array of markers. It is wonderful if the patient has the strength to fill a piece of paper with color and perhaps add a few different shades to liven up the experience of color. We may feel monochromatic, but even within purple there is lilac, lavender, violet and a royal hue. The statement, "I am mid-morning," has its own qualities, too. It is certainly different to the midnight hour. This is a good way to begin, especially if you want to move into another modality such as poetry or movement. Such a beginning might elicit important or comforting memories and be a departure point for more inquiry.

Animals and historical figures as the baseline concept usually need more time as they are more complicated to draw.

Sometimes patients need help beginning their drawings, especially animals and figures. "I know what a camel looks like, but this one is deformed and I want him to look more like a camel!" Help the patients out if they ask but be sure you tell them exactly what you might do before you begin. For example, "I think his head needs to be a bit more upright; what do you think? Shall we use pencil?" Movement is a very fine way to get started, too. A child can easily make a trunk sway, or move their head like a bird. It is a humorous approach to jump into movement and great fun if the mood is "up." Children will definitely respond to the animal idea, but not so much to the historical figure (remember their frame of reference is not the same as an adult's). Colors are a more abstract idea and probably more appropriate for teens or adults. However, presenting a concrete suggestion by holding out an array of colors makes it easier for children to grasp.

Movement mirroring

♦ ♦ ♦ Group
I+ All ages (ambulatory activity)

Allow the group to divide into pairs. Follow a pre-determined theme such as "move your pain." One person moves however they want while imagining that they are the full embodiment of their physical pain. Their partner faces them and mirrors them simultaneously, moving their body the same way. Allow plenty of time so that the participants can go beyond rushed, self-conscious movements. Share and then switch.

Variations

1. This activity can also be done with patients who are wheelchair-bound or unable to stand for protracted periods. Instead of standing, they can sit and hold an object and move their hand or arm around. Partners can again mirror the movements. It is still an intimate exercise that requires concentration, but it does not need to be physically taxing. It is very helpful to keep the mood quiet, so that the activity is mainly communicated through movement rather than through speech. Good objects to hold include lightweight items such as streamers or feathers—something that exaggerates the movement without physically stressing the individual.

2. Mirroring sound: The exercise can be done a second time, but this time sounds can be added. SSSSSS or hmpf, ooooo or ahhhhh! Vocalizations and "sound effects" can add another expressive quality to this activity. This is a further way to engage those who are not very mobile or who might feel too self-conscious to begin with movement. Movement requires that the individual be comfortable with their own body as well as someone looking at them intently.

Pointers

Oftentimes patients feel that their pain is specific to only a few places in their body, but even a little pain in the knee, for example, affects their entire wellbeing. Allowing the pain to have a bigger, fuller presence and to express it through movement, allows the patient to learn more about their pain.

One common technique for lessening the experience of pain is for patients to describe their pain as fully as possible. What color is it? How would it look? Does it have a texture? Temperature? A name? A sound? A movement? Is it rhythmic, steady, pulsing, sharp? When the patient moves the pain in this exercise, the patient is allowing the pain to express itself in ways *other than through pain channels*. In other words, the pain is present, but it is not hurting.

An important factor in this activity is that the patient is in control of the "imagined pain," as the patient can move the pain any way he or she wants, whereas in daily life it may always have been the patient's experience that the pain moves him/her. Because of these factors, this activity can be empowering and possibly also reduce the patient's actual experience of pain.

Children tend to be more active. The trick here is to keep the concentration going. Intimate contact with only one other individual might feel too overwhelming. Take a hint from "Mother May I" or "Follow the Leader"; try one child in front of the whole group. This keeps the playful "game" quality of the active principle in the exercise and feels similar to a game the children probably already know. This familiarity with the game makes it easy for others to join in. Some children (and adults too) can be very self-conscious, especially if they are dealing with a disability or serious illness. Being in front of the group may make them feel too vulnerable. Take account of this when you choose someone to stand out in front or ask for a volunteer.

My favorite room

♦ ♦ ♦ Group
♦ Individuals
⤵ Bedside
1+ All ages, including seniors

Materials

- Paper

- Colored pencils

- Markers

This activity can begin with a guided imagery meditation that leads the patient to their favorite childhood room. Let them spend plenty of time in the meditation, paying attention to all the details of the room: size, color of the walls, windows, view, light, floor, ceiling, decorative accents, furniture, etc. Now focus on the sensory elements: smells, textures, feelings about the place. Is anyone else there? A childhood kitchen, for example, may be full of family and the smell of cookies baking, etc. The patient can either write about the room with evocative adjectives, or draw colorful images of that special place.

Pointers

This is a comforting, easy exercise for patients. It is non-threatening and memory-based. It can be fairly quick or quite long, depending on how deeply the patient wants to connect with the images.

My life

††† Group
† Individuals
⤵ Bedside
14+ Age 14 and upwards

Materials

- An assortment of papers

- Pencils

- Glue

- Pens

- Ephemera

When the patient feels comfortable, do a life review. Where have I been, where am I going? Explore through art materials.

Pointers

Although this seems like a self-explanatory exercise, self-reflection is a critical thinking skill that one develops. Children are not necessarily ready to self-reflect until they are 16 or 17. So with younger patients it is good to help them start thinking by identifying objects that have meaning for them. Did you have a favorite stuffed animal when you were little? What was your favorite song and why? What is your favorite food? Concrete examples give them a chance to hook into something "real." It is also helpful to go backwards. Where are you now? Where were you last year at this time, etc.?

If one is sick, the current crisis is a huge presence in their biography. Adults will probably welcome the chance to speak about it, but be forewarned, many patients are not yet ready to talk about what is going on, or *they may not yet know.* This is when a pre-verbal method of communication—images, gestures, or sounds—may be most helpful. It might also be good to set up a time frame, such as birth, childhood, adolescence, adulthood, now and future, or any permutation thereof. This gives you a framework in which to hold an entire life.

Passages

♦ ♦ ♦ Group
♦ Individuals
↶ Bedside
1+ All ages

Materials

- 12" x 18" sheet of white paper
- Colored pencils or pens
- Cut-out images
- Glue or paste
- Ephemera (small cut-outs, metallic paper, bits of paper ribbon, etc.)

Begin the session with a guided imagery exercise that includes "going through a door to a safe or comfortable place." Take the sheet of paper and fold the sides into the center. This creates a double-door "entryway." Imagine a door or gate and have the patient draw it on the front "closed" panels. Then open the door or gate and draw or collage on the exposed piece of paper what lies beyond.

Variations

The four corners of the sheet can be folded to the center, which also creates an opening, but one which is not a door or gateway. This is a bit more abstract and playful.

For patients who are ready to work with more difficult personal material, the place beyond the closed doors can be described as pain, or shadow material. It can be looked at, but the patient is able to close the doors on it whenever they need. This is a simple way to give a patient control. In this case it would be better not to use the doorway metaphor in the guided imagery, but instead to bring the activity as something separate from the relaxation portion of the session.

Past, present and future

- Individuals
- Bedside
- **12+** Age 12 and upwards, including seniors
- ☑ Can be made for the patient

Materials

- Cut-out images attached to index cards

- Postcards

- Variation: plain paper

- Glue

- Colored pencils

- Felt-tip pens, etc.

Hand the patient a random assortment of image cards (either postcards, or images glued to index cards). Encourage the patient to pick five or six images he/she likes or that catch his/her attention. After the selection lay the images out and then ask the patient to narrow the choice to three images that seem particularly interesting. Then ask which picture is most reminiscent of the past. Pay attention to mood, color, the content of the image (Is it a landscape? If so, where is it? What is the time of day? Are there figures in the image? Who are they?) With the two other images, ask the patient which most accurately represents the present and which the future? Repeat the process with the questions about the images.

Variations

1. Choose just one image and focus on that time period. Place the image in the center of a piece of paper at least three times the size of the image. Allow the patient to extend the image out to the edges of the paper using pens and pencils, thereby creating a context for the image (see Image cards, p.71).

2. The images can also be placed in a "book" so that there is room to write. Simple books can be folded, stapled or sewn together with a big needle and button thread. This is a good choice for a longer-term project.

Pointers

This can be a very long activity if the patient decides to take time and approach it very thoughtfully. You might have time to cover only one time period in a session. If this is the case, the exercise can be reduced to only one card, as in the Image card activty (see p.71) or extended over several sessions, each time addressing a different time of life. It is good not to have too many images to choose from—20 to 30 is plenty. Do not hand your patient magazines or books to cut up. It is too distracting since patients may start reading the articles and the session can degrade into conversation. It is much better to keep on track by providing only what you need. It is helpful to have image cards in piles already sorted by age group. It is, for example, important to keep any disturbing images out of the hands of younger patients.

Person/plant

♦ ♦ ♦ Group
♦ Individuals
⤴ Bedside
10+ Age 10 and upwards

Materials

- Paper
- Colored pens
- Pencils
- Oil pastels
- Tissue paper
- Pipe cleaners

Ask your patient to think of someone who has been important in his/her life. Then, using the art materials, ask them to create an imaginative flower or plant to symbolize that person.

Variations

1. This is also fun to do as a collage or, for something quick, it can be done with tissue, glue and pipe cleaners. The patient can then have a flower to hold, or stand, in a vase next to their bed. This is nice when there is not enough wall space to hang a big piece; they can still feel the presence of the individual near them. For patients who are in intensive care or oncology units, where they cannot have live flowers, this is an especially valuable activity.

2. Patients can also create a vase full of "friends and family," each flower representing a different person.

Pointers

This is a useful exercise for a patient new to you. It is not too self-disclosing for a first session, and patients usually pick an individual who is a comforting presence. For individuals who may be too ill to make the flower, the expressive arts practitioner can create the flower under the direction of the patient. Tissue paper and pipe cleaners are very forgiving materials that can be adjusted easily before, during and after the project is completed.

Pipe cleaner headdresses

♦ ♦ ♦ Group
♦ Individuals
↪ Bedside
1+ All ages
☑ Can be made for the patient

Materials

- Pipe cleaners

- Colored construction paper

- Colored pencils

- Tape

- Glue

- Fun ephemera: feathers, glitter, etc.

Lead patients through a relaxing meditation which ends with a journey. As he imagines himself walking along, he becomes aware of a headdress on his head that has everything needed for the journey. These items can be as diverse as a sense of humor, or as serious as a map. At the end of the meditation ask him to construct the headdress out of pipe cleaners and encourage the patient to invite fantasy and play into his construction.

Variations

For another satisfying project you can have pre-made sets available that come in a paper bag. Inside are all the materials needed to create a "travel kit." The bag can then become the journey's suitcase and the materials can be turned into everything that is needed for the journey. This is a very quick set-up for a group activity where you may not have time to lay out materials ahead of time.

Pointers

This is a fabulous group activity that is especially fun for a celebratory event. It is also a good send-off activity at the end of a series of group sessions that encourages patients to think about the future and moving on. Seniors, as well as children, love this activity and the more creative and unusual bits you can find to include in the set-up, the more fun the individuals will have. Be careful not to use small pieces with young children.

Plaster masks

† † † Group
† Individuals
14+ Age 14 and upwards

Materials

- Plaster mask-making materials (plaster bandage materials)

- Water

- Wash basin

- Wash cloths

- Vaseline

- Paints and brushes

- Decorative materials such as glitter and feathers

- Glue

- CD or tape player with relaxing music

- Elastic

- Hand mirror

Begin session with a "body scan" visualization that encourages each patient to relax and explore their persona. Divide the group into pairs and play relaxing and centering music to support the patients in the process. Taking turns, each person will create a mask for his or her partner using plaster bandage mask technique. Partners should communicate with one another about the form they would like their mask to take. Do they want it to be a realistic representation of their form? Are there any special features they want expressed in the architecture of the mask?

If someone is uncomfortable with the idea of their mouth being covered, or if time is short, they should consider making a half mask instead, to cover only the nose, but not the mouth or chin. All the communication between partners has to happen before the plaster process begins, because once it has begun it is nearly impossible for the "maskee" to speak, or indicate artistic choices. After this point, simple questions can be answered by pre-arranged hand signals.

Be sure to follow any special directions that come with the plaster bandage product you purchase but broadly this is the method to follow:

1. Cover the face with Vaseline, paying special attention to the eyebrows and any other facial hair. If the eyebrows or moustache are very bushy there is a strong possibility that the hairs might get caught in the plaster and that will hurt when the mask is removed. So they must be well covered with Vaseline.

2. Cut a selection of different sized strips of plaster bandage.

3. Dip a few strips in a basin of warm water. Gently squeeze out excess water with your fingers. Place on the face. Be careful not to place strips over the eyes or nostrils.

4. Continue overlapping strips until you achieve the thickness and configuration you desire.

5. Allow the mask to dry in place for at least 10 to 15 minutes. As the plaster sets, it heats up and usually feels rather pleasant.

6. When it feels fairly dry, carefully lift the mask from the face and allow it to dry further.

When dry, the patients should be directed to embellish their mask with a new persona that represents what they need specifically for healing, such as "warrior" or "healer." Switch partners. Have a wide variety of colors and decorative materials opened up and laid out on the table so that all the possibilities are right at the patient's fingertips. Take a break after the decoration is complete. When the patients return ask them to embody the new persona by wearing the mask. Take time for the partners to share the experience with each other as well as with the group.

This project requires several hours. It can be done in one day-long session with a mid-morning break, lunch break and afternoon break, or it can be divided up into several sessions: one for making masks, one for decorating and one for sharing with the group.

Take into consideration drying time as well as time for the group to just sit and breathe out after the mask-making portion.

Variations

1. When the masks are completed, individuals can spend time writing letters to their masks.

2. In addition they can embody their masks for the group or partner by moving around the room with the mask on. Their movements can be witnessed by their partners or by the group.

Pointers

Mask-making is a long, messy process that is not suitable for the bedside. Plaster masks are best made with groups who know and trust one another, because it is an intimate activity where the patients touch each other's faces.

It can be daunting for some patients to have masks made for them. They need to be very relaxed and comfortable with their partners. Some might feel claustrophobic while their mask is being made. In this case it is much better to make half masks (see above). Keeping the nose and eye openings quite large can also help with the comfort level. If an individual is simply not comfortable with the process, have a commercially made mask available for them to decorate, or they can make one of the cut-out paper masks suggested in Appendix A, Patterns and Projects (p.195). That way they can still participate in the process and their discomfort will not be as likely to alter the mood in the group. If you think this might be a possibility, be sure to offer this choice right at the beginning of the session.

Poetry series

✦ ✦ ✦ Group
✦ Individuals
⤴ Bedside
10+ Age 10 and upwards

Materials

- High quality paper cut into sheets
- Raffia
- Scissors
- Pens and pencils
- Coloring materials

Begin with a relaxing visualization. The goal is to create a folded accordion book filled with images and poetry. The poetry can be written on one long sheet that is then folded accordion style into sections. This technique is better suited to poetry and drawings, not collage images. The sheet can be folded first, before the poem is written. That way there are discrete sections and the patient will not be tempted to make drawings over the folds. Small holes can be punched into the left edge of the folded-up accordion book and tied up with raffia (see Bookmaking techniques, p.88) for more ideas. See p.92 for more on writing poetry.

Variations

1. It can be helpful to provide a stack of pre-cut images as a source of inspiration for the patients, or to help them illustrate their poetry after it is finished. Sometimes, quick, first-thing-that-pops-into-your-head words are the best way to get started. In that case it is helpful to begin the session with a very relaxing, meditative visualization.

2. It can also be nice to play relaxing music during the meditation. Gauge your patients and see whether they might be better served by starting with the creation of an image as a way to elicit poetry. The book can be made in one session or over a period of time.

3. For a group, photocopy enough copies of all the poems so that each patient can go home with poems created by themselves as well as the other members of the group.

Pointers

Writing a poem can seem a daunting task to someone who does not feel that they are particularly creative. Remind them that it does not have to rhyme or even make "sense"; it should simply be a reflection of where they are at the moment. It does not need a particular form or rhyme scheme, but if they want it to rhyme, a pocket rhyming dictionary could be a good thing to have on hand. It is easy to stimulate the imagination with images or words. For quick inspiration, pull out your stack of images glued to index cards, or a list of your favorite adjectives, verbs and adverbs.

Rather than draw or write directly onto the accordion book, the patient can also cut out everything beforehand, both the images as well as the poems, and then mount them in the accordion book. This way if there is a mistake, the patient can make corrections without altering the integrity of the book.

Polarities

† † † Group
† Individuals
↩ Bedside
1+ All ages

Materials

- One sheet of paper 12" x 18"
- Colored drawing materials

The concept here is to work with opposites. They can be personal likes and dislikes or impersonal opposites, either abstract or concrete, such as peace and war, chaos and order, apple pie and brussel sprouts, etc.

Holding the paper with the long axis being the bottom, fold the sides so that they meet in the middle like doors. Have the patients draw whatever they like on the outside—an abstract idea or a concrete reality such as peace, harmony, light, happiness, your favorite pet, etc. and on the inside whatever they dislike—possibly war, chaos, anger, etc. The concept inside should be the opposite of what is on the outside. Take time to share.

Variations

Instead of a folded piece of paper with an inside and an outside, a paper plate or a square piece of card can be used. Place the square card on the table like a diamond with one corner facing the patient. The patient paints one image on one side and one on the other. A simple mobile can be made by punching a hole in the top of the paper and suspending it with string. As it moves in the wind, the truth that opposites can exist simultaneously is revealed. Similarly opposite images can be drawn on each side of a paper plate, which can be suspended on string as a mobile.

Pointers

Dislikes can be very charged for the patients. Make sure that you have lots of time to explore in conversation as well as artwork the ideas that emerge. At the end, the patients should definitely choose whether to leave the "dislikes" visible. Patients should not be forced to confront what they perceive as dark. If a patient decides not to work with charged material there are still many other polar opposites available: hot and cold, thick and thin, etc.

Portrait of wellbeing

♦ ♦ ♦ Group
♦ Individuals
⤶ Bedside
1+ All ages

Materials

- Butcher paper
- Colored drawing materials

This activity is intended to be done life size, but there is a smaller version under variations that is more appropriate for the bedside or for patients who may not be ambulatory or able to lie on the floor.

Lay out the appropriate sized paper. Ask the patient to envision themselves in optimum health. Then ask them to think who is their supportive and caring community. When ready, using a very large piece of butcher paper, ask the patient to lie in the middle of the paper and trace around their form. The patient can then fill in the area of discomfort or disease, thoughts and feelings—whatever they are motivated to include. At the end, actual photos of supportive community members, friends and family, or just their names, can be added to the margins of the image.

Variations

1. For those who need a smaller version of the portrait, you can either ask them to draw the outline of their body on a plain sheet of paper or use one of the pre-drawn images (photocopy and enlarge to any size you wish) available under Appendix A: Projects and Patterns, p.195.

2. This exercise can be used to get in touch with the patient's discomfort or disease, though this might require more time for self-reflection. Patients benefit from reminders that they are whole and that front, back, sides, top and bottom are all connected. A good metaphor is to look at the outline and imagine that the patient is a transparent pool of water and the longer one looks into the "pool," the more one sees. This can give them the opportunity to look more deeply and bypass the tendency to focus on the surface or on what they think they already know about themselves.

Pointers

Patients frequently refer to themselves by painting a front view of themselves, i.e. what they see when they look in a mirror. It is helpful to note that there is no impenetrable shield that separates one's front from one's back.

If the patient's drawing includes areas of disease, it is helpful to note that the patient is more than the disease and that the illness is a small part of the whole person.

Random acts of kindness

† † † Group
† Individuals
↪ Bedside
I+ All ages

Materials

- Anything goes: be as creative as you wish

Ask the patient to think of random acts of kindness that have touched them and represent them artistically.

Represent these in simple drawings, as stories, poetry, collages, etc.

Variations

The patient might decide to thank particular individuals who have been supportive and turn the art work into a thank-you note.

Pointers

This exercise can awaken the desire to thank individuals who have been especially helpful and supportive. For patients with terminal illnesses this can be very challenging and where one patient may be ready, another may never be. Tread softly. It is often easier to keep the idea more abstract and less personal, such as thanking the unknown girl who helped the patient across the street last Tuesday, rather than an individual the patient knows or interacts with on a regular basis. By keeping it abstract, it also highlights the goodness in the world. Unfortunately, it is the tragedies and violent acts that are blared on every TV channel in the hospital. Create your own good news and with your patients celebrate the "unsung heroes" with art.

Rosebush

♦ ♦ ♦ Group
♦ Individuals
⤺ Bedside
8+ Age 8 and upwards

Materials

• Paper

• Colored pencils

• Oil pastels

Lead the patient in a meditation where they envisage themselves as a rosebush. Be sure to leave all the particulars to their own imagination by allowing them to answer guided questions that help them see the detail of their rose: What do you look like? What color are the blooms? Are you a rose in winter? Do you have thorns? Which type of bush are you—a climber, a rambler, a standard, a hedge, a carpet rose? Allow the patient to express the vibrant color of the flower and the structure of the plant. The creamy texture of oil pastels and their brilliant hues can be very appealing for this exercise.

Variations

A completely different take on this exercise is to stress the growth factor of the plant. This can be experienced through wet-on-wet watercolor method (see Watercolor techniques, p.99). This has a completely different feel than vibrant color, but is excellent for moving beyond issues of control as the image is dependent on the brushstroke as well as the watery surface. As the colors blend and flow the patient can feel the experience of the plant. Water is the element that holds the plant together, that allows it to stand upright or wilt. It delivers food and carbon dioxide, etc.

For this you need a large space where you can leave the paintings to dry overnight. For wet-on-wet method, be sure to use high quality paper with rag content. Mix the paints with water so that they have enough vibrancy but are still liquid. Provide two reds, one yellow, and two blues. Be sure to put out jars of clean water, too. Place several sheets in a basin of water. Then lay them out on a waterproof craft board so that they can be picked up and moved while they are still wet. Press the paper against the surface, removing any trapped air bubbles. Allow the colors to mix freely on the page, creating all the hues needed. Patients can paint an entire rosebush or just a single rose. Save plenty of time for the clean-up.

Pointers

The goal of this activity is for the patients to see themselves in detail as a rosebush. Everything on the page carries significance: the size of the thorns, the size of the blooms, etc.

The experience of wet-on-wet (see Variations, above) is very freeing and the antithesis of drawing with a pencil—it is so free that the image may seem to run off the page. This is a great introduction to painting, because it is really more of a color experience than an experience in form. The rosebush or single rose is also easy to draw. The blooms are really big circles and the shapes of leaves and stems live vividly in most people's imagination.

Round robin

 ♦ ♦ ♦ Group
16+ Age 16 and upwards

Materials

- A wide selection of colored felt-tip pens
- A sheet of paper for each participant

The group sits in a circle or around a large table. Each person chooses a different color felt-tip pen. Everyone begins by drawing something—from a line to an image on their sheet of paper. The drawings that emerge might range from completely abstract to completely representational. You can instruct the group either to add one line at a time or draw for a pre-determined length of time. The goal is to pass the papers around the table, thereby allowing everyone to add to each paper until each member of the group has had the chance to add something to each drawing. Logistically it is best for you or an elected member of the group to call "time" at which point the papers are passed to the right.

Variations

1. The group drawing can also be done with one large single sheet of paper, but the participants have to be patient while one person at a time draws. This might be difficult for children or for seniors with dementia.

2. Alternatively, you can give the patients an idea for the image—such as a skyscraper, or island, or city. If you choose this option, reserve plenty of time to talk about the image at the end of the session. If you have a studio which patients visit, a large piece of paper can always be left out for a pre-determined amount of time. Individuals can add to it "at will."

3. Each participant takes a different color of construction paper and a marker. He/she then cuts or tears the paper into pieces and glues one piece onto a 12"x18" piece of paper. Pass that sheet onto the next person who adds their piece of colored paper, and so forth. When all have participated, it then goes around again and each one adds their own marker color to each sheet.

4. Any individual can have the right to call "cut" when they think the piece is finished. They take on the responsibility of explaining what they see and why they think it is finished. The play begins again with a fresh sheet handed to the person on the right.

Pointers

The time frame is the real key. Long increments may become boring and short increments can make the patients anxious or playful. It certainly becomes more of a game when the increments are not constant and switch back and forth between long, short and in-between. For that method the timekeeper should announce the time before the "play" starts. For example "30 seconds, please begin."

Be aware of the mood of the group. You might want to do several rounds, or not. It can be quick and energizing, or slow and meditative. Check in with them. Make sure everyone is engaged. The goal is to keep them creating rather than chatting. The more playful the mood, the more chatting you will have, and you should be clear what the needs of the group are. Maybe a very social, chatty group is just the right thing.

Sanctuary

♦ ♦ ♦ Group
♦ Individuals
↩ Bedside
16+ Age 16 and upwards

Materials

- Paper
- White glue
- Brushes
- Colored tissue paper
- Card stock
- Wood scraps
- Fast-drying clay

Lay out all the materials within easy reach of the participants. Place a piece of card stock at each place. This will act as the base (or work surface) for the project. This way everyone has access to a wide variety of materials. Some may prefer to use only clay and others will prefer tissue and card stock, or a combination of all the different materials.

The object is to create a three-dimensional sanctuary on a large sheet, using tissue paper and white glue or fast-drying clay. The session should begin with a guided imagery that takes the patient to a "sanctuary." Remember that a sanctuary need not necessarily be a traditional building; it could, for some people, be a place in nature. So, as the patients envisage their sanctuary, ask "What is above you? Below? On the sides? Are there walls? An entrance?" Keep it vague so that the patient feels completely free in his/her imagination to create his/her own sanctuary.

Pointers

Guide the patient to build something that can be finished in one sitting. Let them give you a simple description before they begin and with that you might be able to guide them to appropriate materials. For example, something tall would be easier to form out of crushed tissue than built up out of clay. Clay is also heavy, so they would need to begin with stout card stock, wood or foam core for the base. This makes it easier to transport.

Saying goodbye

♦ ♦ ♦ Group
♦ Individuals
↪ Bedside
18+ Age 18 and upwards

Materials

- Paper

- Colored pens and pencils

This begins with a relaxation and guided imagery that encourages the patient to see themselves crossing backward over a bridge. Instruct them to say "See you again" to ones they have loved and "goodbye" to those who have hurt them. Ask them to now turn around, cross the bridge and move toward the new shore. Illustrate the new terrain using a palette of bright colors.

Variations

Imagine crossing the bridge with those who love and support you and wave "goodbye" to those who are not supportive of your new lifestyle/health choices. Take plenty of time for sharing in case the patient wants to say more than "goodbye."

Pointers

This is a good exercise for those ready to move on in their lives. It is a good choice for patients who have struggled with addiction or abuse. Although it may seem to relate more to emotional than medical issues, health is a continuum. The social group can support healing, or they can even hinder it.

Saying "No" brings opportunity

††† Group

† Individuals

↩ Bedside

16+ Age 16 and upwards

Materials

- A copy of the short version of Lady Ragnell and Sir Gawain from *Inward Journey: Art as Therapy* by Margaret Keyes, published by Open Court Publishing Company (1985)

- Paper

- Colored pencils or pens

After reading the selection, ask the patients to reflect on the idea that saying "No" to something means saying "Yes" to something else. Have them relate that to a decision or opportunity in their lives. These new opportunities can be explored through poetry, movement or a visual medium. Go with the flow here and offer lots of different modalities from movement to visual art to music. Consider following this with the polarity exercise (see p.169) with different choices on either side: "No" on one side allows for a "Yes" on the opposite side. This can even be very concrete, such as no cake and ice cream for the diabetic, but yes to all sorts of ways to explore healthy eating—a new recipe perhaps?

Pointers

Patients often have to deal with health restrictions in their lives. It is easy to get caught up with "I can't" and this activity gives them the opportunity to see that the "I can't" is really "I'd rather." Choices, whether involuntary or voluntary, are opportunities and the journey to health often involves acting on new, healthier, choices.

Seasonal mandala

♦ ♦ ♦ Group
♦ Individuals
⟿ Bedside
14+ Age 14 and upwards

Materials

• Pictures already cut from magazines

• Large paper cut into a circle (or cardboard rounds that go under cakes or pizzas)

• Scissors

• Glue sticks

Give the patients the large circle. Ask them to divide their circle into four quadrants. Ask them to consider how the four seasons are evident in their lives. Which emotional or physical season are they in now? Do they have different seasons for different relationships? What constitutes their Summer, Fall, Winter, Spring? Using the collage pictures, illustrate each season in a personal way in the four quadrants.

Pointers

The mandala form safely holds the entirety of the patient's experience within the integrating form of the circle. There is no beginning, no end, just the complete whole. Winter and Summer may seem like opposites, but in the mandala it is clear that they are connected. The circular cardboard is an easy way to create a safe boundary for the entire scope of the patient's experience. Even the toughest things are held together in a circle, side by side with what may at first appear as the polar opposite. This concept may not be obvious to the patient and it is not necessary to point it out to them either. The mandala form works on them unconsciously.

Seed packets

♦ ♦ ♦ Group
♦ Individuals
↩ Bedside
8+ Age 8 and upwards, including seniors

Materials

- Large colored envelope
- Slips of colored paper
- Pen
- Markers

Ask the patients to imagine themselves as a flower—one that the world has never seen. What color, shape, size, scent, would they have? Draw this on the outside of the envelope. This envelope becomes the "seed packet." On the back of the envelope (if one is able to write small) or on slips of paper that fit inside the envelope, spell out the directions necessary for your growth? This could be: "I need to be kissed at least once a day," "I need chocolate," "I need Hawaiian sunlight" etc.

Variations

For long-term groups this activity could be followed by planting real seeds and then noting the care they require, just like those who planted them.

Pointers

This activity will be meaningful to older people who know what seed packets look like or to individuals who love to garden. Gardening is one of the most popular hobbies and the metaphor will appeal to everyone. However, there are those who have never had the opportunity to garden or to see a real seed packet. It might be helpful to bring along a real seed packet so that they can see what it looks like and then explore from there.

Self as landscape

♦ ♦ ♦ Group
♦ Individuals
↩ Bedside
16+ Age 16 and upwards

Materials

- Paper
- Coloring materials
- Paints and brushes
- Tissue paper
- Clay
- Tongue depressors

Have the patients imagine themselves as a landscape. You can launch right in or lead them in a guided imagery that allows them to walk through their own landscape. Allow them to pay attention to oceans and mountains, streams, rivers and valleys, plains, desert and forest. They can then build their landscape in either two or three dimensions. Let them take you on a walk through the landscape as a "tour guide" and point out to you what is special in their environment.

Building an entire landscape can take several sessions, depending on how detailed the group chooses to be. It might be helpful for them to take notes when they come out of meditation. Did they have any ideas they want to record?

Variations

1. For individuals, instead of choosing an entire landscape, let the patient focus on a mountain, or a stream, or the ocean. Then they can imagine walking up this mountain, following the course of the stream or swimming in the ocean. As you lead them through a meditation you can have them pause on the side of the mountain near a big rock or under a tree. Be as creative as you can in allowing them to feel the landscape around them. Is there a body of water nearby? Is it a pond? Lake? Ocean? There they will meet all sorts of wildlife and experience waves, dark depths and shallows. When they follow the course of a stream it takes them to many places. What is the source like? Does it join other streams? Does it go through a city? End in a lake? Peter out?

2. A simple way to do this exercise if time is short is to suggest they draw a map and label all the prominent features.

Pointers

This is an exercise that uses the metaphor of landscape to encourage self-knowledge. There may be places that are completely clear and well defined for the patient and others that are murky or less distinct. Helping them to gain a clearer understanding of who they are can help them to understand themselves in relation to their illness. Do not hesitate to ask questions about special features. Does the illness show up as a particular geographical feature, or as a color—or even blank space? These are always good points for a discussion.

Self cards

♦ ♦ ♦ Group
♦ Individuals
↶ Bedside
1+ All ages

Materials

- Heavy stock paper
- Coloring materials

Have the patients fold a piece of paper into a card. On the outside ask them to draw the way they feel the world sees them. It can be abstract; it does not need to be a "realist" image. On the inside illustrate the way they feel. Are the two related?

Pointers

I would avoid doing this with any patient who may be struggling with body image unless you have an ongoing relationship with them, as you might get yourself into water that is too deep to address in just one session. For a patient recovering from a disfiguring injury or suffering from an eating disorder, this can be a potent exercise, so make sure that you give plenty of time to dialogue. Be sure that if you choose to do this exercise with any patient where body image is a concern that you are sensitive to the material that may arise and are able either to give the patient the support he/she needs or make sure the hospital can continue to support them in their process.

Self symbol

✦ ✦ ✦ Group
14+ Age 14 and upwards

Materials

- Paper
- Coloring materials
- Access to a copier

Ask each person in the group to imagine a symbol that would represent himself/herself. If the idea of a symbol seems too abstract they can think of an iconic image such as the Empire State Building, or a logo, trademark or branding idea such as they might see in an advertising campaign. Each person should draw their own symbol on paper. Make enough copies of each symbol so that everyone will end up with a stack of images, one for each member of the group. They can then cut them out and each person can make an individual collage with the group's symbols. Give the participants plenty of time to share their distinct collages with the group.

Variations

Before collages are assembled the group can lay the individual symbols out on the table and group them into similar ideas: a selection of circle images or nature symbols, etc. Patterns might begin to emerge. Several individuals might be thinking along the same lines, even though they may be sitting at opposite ends of the room. Certain group members might use the same color, etc.

A laundry line of symbols can be strung across the room. Twine and clothes pins or paper clips are all one would need. This might be a good exercise to begin a series of group sessions. By the end of several weeks or months the participants might choose a different symbol than the one they began with and that would be the departure point for critical, self-reflective work.

Special place

♦ ♦ ♦ Group
♦ Individuals
↩ Bedside
1+ All ages

Materials

- Paper
- Pens and pencils
- Collage images

Think of a special place in your life that brings forth strong memories, such as an eventful holiday, or grandma's house. Talk about the theme and then use the art materials to show the memories.

Variations

1. Write a letter to someone as if you were there in that special place.

2. Structure the exercise to work with a place that may be frightening or hold unpleasant memories. In this case, it might be enough to do a very simple image and for the patient to write a letter of encouragement and support to themselves in the past. I suggest this option only if you have an ongoing therapeutic relationship with the patient as memories may continue to arise days, and even weeks, later. In the case of physical trauma, a frightening place may even be the site of the accident, and this could still carry tremendous charge for the patient, especially if there is guilt associated with the event or if the outcome and healing is uncertain. Go slowly and carefully, providing constant support and presence if you choose to go there.

Pointers

This is an especially pleasant exercise for children, and good cues may be as simple as "your favorite holiday" or "your best friend's house."

Stages of life

♦ ♦ ♦ Group
♦ Individuals
⤴ Bedside
18+ Age 18 and upwards, including seniors

Materials

- Paper and pen for writing
- Paper and coloring materials for the art project
- String or raffia

Begin with a relaxing meditation that creates a feeling of comfort and repose. Then guide the patients to think about the different stages of their lives. They should consider these from their own, deep, inner selves. Where are the turning points? The plateaus?

Fold high quality paper in half to create a book with four leaves or more. This can be tied off like a journal by wrapping a piece of raffia or string around the center to create a binding. Begin with journaling time and then either the journal entries could be illustrated or the patient could take a fresh sheet of paper and make separate illustrations.

Pointers

A journaling activity is a nice way to ease reluctant patients into art-making. Journaling is familiar. For someone who is less comfortable with drawing, simple little illustrations in the margins of the journal are an effective way to move into image-making.

This is a pleasant exercise for seniors. Those unable to use their hands can dictate to you and you can become the "scribe" and also help them "illuminate" their entries.

Story-telling

♦ ♦ ♦ Group
♦ Individuals
↵ Bedside
I+ All ages

Materials

- Paper
- Paint
- Crayons
- Colored pencils and pens
- Tissue paper
- Glitter
- Ephemera

The individual is asked to tell the story of their illness as a fantasy. They should feel free to make up characters and outcomes and embellish their story any way they desire. Then they can present themes from the story artistically in any medium they choose. Groups may choose to create a story together.

Variations

This concept can carry over to many sessions if you choose and can become quite elaborate. The initial session can be a time to focus on the creation of the story, and if the patient chooses he/she can journal or illustrate the major ideas. This gestational process takes time. Following sessions can focus on the creation of artwork, and if the patient is so moved it can also be presented as drama. Simple hand puppets are another fun way to make this come alive, e.g. puppets made "Fandango" style with brown paper lunch bags. If your patient wants to keep going with the theme, let it play out until he/she feels that his/her story has been completely revealed.

Pointers

If you do not have the luxury of many sessions, it might be wise to focus on one aspect of the story. It might also help to read a fairy tale to help wake up the story-telling juices (e.g. Grimm's Fairy Tales), or provide a few stock characters to get the process rolling, such as the prince, simpleton, princess, witch, king and dragon. Allow the patient to create a story around the characters he/she chooses. A simple story line could be: the patient could see himself/herself as the simpleton who overcomes obstacles (three trials—a witch, a dragon, etc.) and ends up inheriting the kingdom.

In a group setting it is important to see that each participant's individual voice is heard, whether they contribute to the story or are more involved in the artwork.

Telling your story

♦ ♦ ♦ Group
♦ Individuals
⊸ Bedside
16+ Age 16 and upwards

Materials

• Paper and pen

Story-telling is the basis of expressive arts and most psychotherapy. The patient wants to understand their illness and why it happened so we explore it in as many ways as possible. We usually start every group with introductions and ask people to tell their story briefly. Later on in the group we might ask why they thought they had their illness. In the cancer groups people come up with many interesting reasons such as: my divorce, my job, because I ate chicken, because I was unhappy, because I was asleep.

Writing out a story with a beginning, middle and end is one way for the patient to tell their story. Telling it like a fable or fairy tale (along with illustrations) sometimes gets the imagination going. Following is a template for an instant story that helps the patient formulate the plot. It can be expanded in any way you choose:

1. Once upon a time there was…

2. And every day…

3. Until one day…

4. Because of that…

5. Until finally…

6. Ever since that day…

7. The moral of the story is…

The questions posed by John Graham-Pole, MD in his book *Illness and the Art of Creative Self Expression* (2000, pp.14–15) also lend great structure to the narrative process and help the patient engage more deeply. An assortment of his questions follow:

1. When do you think this illness first took up occupancy inside you?

2. Who else is involved?

3. Why do you think it picked you out of the pack?

4. Does it remind you of anything that happened to you in your past?

5. If your illness could talk to you, what do you think it would say?

6. What do you want to tell it in return?

7. If your illness was a play, what kind of play would it be: a tragedy, a whodunit, or a farce?

8. What are the worst things about it?

9. Is you life different in any way since your illness?

10. Is there anything at all good you can say about the situation?

11. What have you learned, if anything, from being sick?

12. Has your illness served any purpose? For you or anyone else?

Remember, it is OK if the patient does not know an answer, or needs more time to think about it. Just one answer may be enough to spark a "Once upon a time…" story, or a painting or drawing. Just keeping a little journal, or miniature book filled with musings might be, in the words of Goldilocks "Just right!"

The road less traveled

ᵢ ᵢ ᵢ Group
ᵢ Individuals
↩ Bedside
21+ Age 21 and upwards, including seniors

Materials

- Paper

- Pencils

- Pens

- Glue

- Tissue paper

Allow the patient to think of a major branching point in his/her life and how taking that path sent him/her in a particular direction in his/her life. The patient can then illustrate the road less traveled…or the fork in the road. Encourage them to use lots of expressive color in their image.

Variations

In this variation the choice is much more abstract, the focus being on the path chosen rather than on the choice made. Begin the session with a guided meditation that leads the patient to a fork in the road. Encourage them to note the landscape, think about where each road might be headed, etc. Allow them to choose one of the roads and follow it for a short distance. Encourage them to notice why they chose that road and then allow them to create the fork in the road and a bit of the new road through a visual medium.

Pointers

This is a very good choice for a new patient or if you might have only one session with a patient. It opens up questions but in a format that allows patients to have a safe, retrospective view of events. The variation is especially good for this because it allows material to emerge slowly and the patient has total control over which path to take. This can be very comforting for someone new to "process-oriented" art.

Voice and gesture

🧍 Individuals
🛏 Bedside
1+ All ages

Let the patient express through voice and gesture his/her name or emotional state. The facilitator then mirrors the movement and intonation of voice. Names carry great significance for us and it can be powerful for someone to say their name with intention.

Variations

1. This can be a short introductory exercise or develop into something larger. The vocal or physical gestures can also be illustrated. Even the vocalizations can be written down as words in colors that intensify the emotional content, such as red for anger, etc.

2. It can also be helpful for the facilitator not only to mirror the name back, but to continue to call it soothingly to the patient as he/she lies in a restful position. Nancy... Nancy... This can evolve into a duet as well: a particular pitch is chosen and the facilitator sings it to the patient. Then the patient sings it back to the facilitator and eventually they overlap and create a duet.

Pointers

This activity can easily be done with bed-bound patients, as movements can be small and done just with the upper torso, head and arms. For vocal gestures, it is helpful to begin with some examples of how we vocalize emotions in daily life: Yippee! Ow! Ooooo! Oh! Hmpf! This idea applies to words as well. Let the patient try to say "happy" with a happy sound, or "sad" with a sad sound. In this way they can see that they are just exaggerating the sound that is already there. Do not try any of the vocal techniques if the patient has breathing issues, or is hoarse or has a sore throat from invasive therapies or infections.

Who sees you?

♦ ♦ ♦ Group
♦ Individuals
↩ Bedside
14+ Age 14 and upwards

Materials

- Paper
- Colored pencils
- Markers
- Tissue paper
- Glue
- Pipe cleaners
- Tongue depressors

Ask the patient, "Of all the people in your life, who is the one person who made you feel seen and worthwhile?" Then the patient will create a visual monument to that person's memory. Leave plenty of time while making the art for the patient to speak about the person. They may tell anecdotes, or remember things they had forgotten.

Variations

1. You can take notes while they are creating art and afterward give them a list of some of the memories or ideas about that individual that came up during the session.

2. Alternatively, you can encourage them to journal after they have completed the piece, write a letter to that person, or construct a poem about them.

Pointers

This is a relatively accessible activity for most people. Encourage them to make a monument to that person, not a portrait of them—for example, a bouquet of flowers.

Word salad

♦ ♦ ♦ Group
♦ Individuals
⤸ Bedside
16+ Age 16 and upwards

Materials

- An envelope full of words cut out from newspapers and magazines. Choose juicy, expressive adjectives and active, lively verbs.

Have the patient choose at random five to ten words and create a song or poem from them.

Variations

1. The patient can choose words one at a time, which often makes for more humor, but nonsense too.

2. The patient may opt to tell a story instead.

Pointers

This is a wonderful first exercise as it can be short and simple or quite elaborate. Be careful to let the patient direct the exercise and ensure they do not get too tired. It is much better to do several short songs or poems, so that they can finish them, rather than taking on a story with length.

Worry box

✝ ✝ ✝ Group
✝ Individuals
↩ Bedside
10+ Age 10 and upwards
☑ Can be made for the patient

Materials

- Paper
- Scissors
- Pencils
- Pens
- Scotch tape
- Ruler
- Magazine pages

Draw an image of a box in which to put your tension, problems and difficulties. For those who need a more concrete solution, a slit can be cut into the image of the box and a little pocket made of paper can be taped to the back of the image, over the slit. The patient can then write down all their worries and tensions on little slips of paper and these can be slipped inside "the box."

Variations

1. In subsequent sessions, open the box and at random pull out one slip of paper and express the worry through art materials.

2. Fold an origami box (see Boxes, p.113) and place little strips of paper inside, each one inscribed with a worry, tension or fear. The box can then sit on the nightstand or be put away out of sight. Glossy magazine pages provide a stout material that makes strong boxes.

3. Create several boxes: one to hold the good things, one to hold the difficult things, and an empty box for new things to come into life.

4. A group can make one large box, or decorate a big box with collage and construction paper, and then each individual can read their stack of worries aloud to the group if they wish (patients may feel that some worries are too intimate to share). Group members put their worries in the box, the idea being that the entire group cares for all its members and together they will hold all of the worries for the individuals. The box can have pride of place at the beginning of group sessions. It can be acknowledged by the entire group with a few seconds of silence. Some may be moved to prayer and others to positive thinking as they reflect on the box.

Pointers

This is a lovely activity that can be adapted to many different situations.

Your favorite meal

† † † Group, including family members or friends
† Individuals
⤸ Bedside
▮⁺ All ages, including seniors

Materials

- Paper
- Drawing materials
- Colored tissue
- Construction paper
- Scissors

Let the patient choose their favorite meal and then have them create this out of art materials. In a group setting each patient can offer a dish for the pot luck.

Variations

Create a dinner party and have the patient create a guest list of friends with whom they can share their special meal.

Pointers

Food usually brings out a festive mood, but with illness, be forewarned that anything can happen. It would be wise to know your patient's restrictions and medical history before beginning. A patient who is pre- or post-op may be on a restricted diet or not allowed anything by mouth at all. However, patients who, for example, might have to avoid sugary foods or salt in their diets can add art "salt" and "sugar" to their heart's content. This is also fun for kids who might be missing their mother's cooking or patients bored with the hospital menu: tapioca on Tuesday and hot dogs on Wednesday.

Your helper

♦ ♦ ♦ Group
♦ Individuals
↩ Bedside
1+ All ages, including seniors

Materials

- Two pieces of paper
- Drawing materials
- Scissors
- Tape

Have the patient imagine that he/she is walking through an opening. On the other side they meet a helper, whatever or whomever that is, who is going to help them change something in their life. With the first piece of paper, create the opening and use scissors so that it will open. On the second piece draw the helper. Be careful to make sure that when the opening is open, the helper is visible. Tape the first piece with the opening on top of the second piece with the image of the helper, so that the opening leads to the helper.

Variations

The patient could write a poem or letter from the helper to himself/herself and that could be taped to the back of the piece.

Appendix A: Patterns and Projects

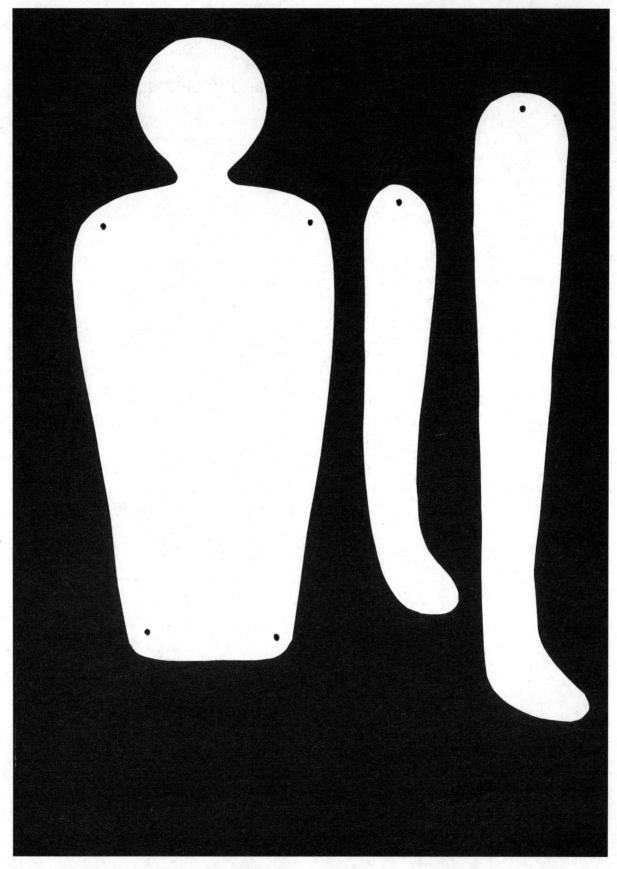

Jointed paper story doll: outline for tracing (see p.148 for more information)

Bird paper mask. Cut out two. Tape the two together at the beak (see p.156 for more information)

Fold and insert
in cheeks

Fold

Fold

Pig paper mask (see p.156 for more information)

Cut out mask to be worn by partner (see p.156 for more information)

Male outline to be copied for Portrait of wellbeing (see p.170 for more information)

Female outline to be copied for Portrait of wellbeing (see p.170 for more information)

Appendix B: Associations and Professional Organizations

US Associations

The following American organizations are all wonderful professional associations with helpful links if you are interested in art therapy, expressive arts, the arts in healthcare settings and professional training:

American Art Therapy Association Inc. (www.arttherapy.org)

American Dance Therapy Association (info@adta.org)

Americans for the Arts (www.artsusa.org)

Association for Anthroposophical Art Therapy in North America (AAATA) (www.phoenixartsgroup.org)

International Expressive Arts Therapy Association (www.ieata.org)

National Association for Drama Therapy (NADT) (www.nadt.org)

National Association for Music Therapy (www.musictherapy.org)

National Association for Poetry Therapy (www.poetrytherapy.org)

National Coalition of Arts Therapies Associations (www.nccata.org)

Performing Arts Medicine Association (PAMA) (www.artsmed.org)

Society for the Arts in Healthcare (www.thesah.org)

International Associations

Arts in Therapy International Alliance (AiTia) (http://arts-in-therapy.blogspot.com)

Association des art-thérapeutes du Québec (AATQ) (www.aatq.org)

Australian Creative Arts Therapy Association (ACATA) (www.acata.org.au)

British Association of Art Therapists (BAAT) (www.baat.org)

British Columbia Art Therapy Association (BCATA) (www.bcarttherapy.com)

Dutch Association of Art Therapy (NVCT) (www.vaktherapie.nl)

European Consortium for Arts Therapies Education (ECArtE) (http://ecarte.info)

German Association of Art Therapy (DGKT) (www.dgkt.de)

International Expressive Arts Therapy Association (IEATA) (www.ieata.org)

International Networking Group of Art Therapists (ING/AT) (www.acteva.com)

International Society for the Psychopathology of Expression and Art Therapy (SIPE) (www.online-art-therapy.com)

International Art Medicine Association (PAMA) (http://members.aol.com/iamaorg/index.html)

Northern Ireland Group for Art as Therapy (NIGAT) (www.nigat.org)

Organizations

These organizations are interested in the arts and healing:

Art as a Healing Force (www.artashealing.org)

Art Heals (www.artheals.org)

Art Force (www.artforce1.org)

Art in Therapy (www.artsintherapy.com)

Center for Journal Therapy (www.journaltherapy.com)

Sound Healers Association (www.healingsounds.com)

Training

Check the associations for professional training. They will know schools which offer specialized training in the various expressive arts, so that you can choose a program that suits your needs.

For week long training in New York City for artists and professionals, contact the Creative Center at info@thecreativecenter.org

For consultants who will advise on all aspects of art in healthcare and for online training contact: The Society for the Arts in Healthcare (www.thesah.org)

Appendix C: References

American Psychiatric Association (1980) *Diagnostic and Statistical Manual of Mental Disorders*, fourth edition. Washington DC: American Psychiatric Association.

Graham-Pole, J. (2000) *Illness and the Art of Creative Self Expression*. Oakland, California: New Harbinger Publications.

Jacobi, J. (1959) *Complex/Archetype/Symbol in the Psychology of C.G.Jung*. Princeton: Princeton University Press.

Jung, C.G. (1973) *Memories, Dreams and Reflection*. Aniela Jaffe (ed.) transl. Richard and Clara Winstonn. New York: Random House.

Keyes, M. (1985) *Inward Journey: Art as Therapy*. Chicago: Open Court Publishing.

Lear, E. (2002) *A Book of Nonsense*. Oxford: Routledge.

Le Navenec, C. and Bridges, L. (2005) *Creating Connections between Nursing Care and the Creative Arts Therapies*. Springfield, Ill.: Charles C. Thomas.

Richards, M.C. (1996) *Opening our Moral Eye*. Hudson, New York: Lindisfarne Press.

Richmond, W. (1997) *Communication Arts*, May–June, *39*. Menlo Park: Coyne and Blanchard.

St Exupery, A. and Howard, R. (transl.) (2000) *The Little Prince*. New York: Harcourt.

Appendix D: Further Reading

Poetry
How to make a poem

Fox, J. (1995) *Poetic Medicine: The Healing Art of Poem Making*. New York: Jeremy P. Tarcher/Putnam.

Fox, J. (1997) *Finding What You Didn't Lose: Expressing Your Truth and Creativity Through Poem Making*. New York: Jeremy P. Tarcher/Putnam.

Poetry we like to use

Lorca, F. G. and Jimenez, J.R. (1993) *Selected Poems*. Robert Bly, transl. Boston: Beacon Press.

Nepo, M. (1994) *Acre of Light: Living with Cancer*. New York: Talman.

Nepo, M. (2004) *Suite for the Living*. Mill Valley, CA: Bread for the Journey.

Oliver, M. (1986) *Dream Work*. Boston: Atlanta Monthly Press.

Oliver, M. (1990) *House of Light*. Boston: Beacon Press.

Oliver, M. (1992) *New and Selected Poems*. Boston: Beacon Press.

Rilke, R. M. (1981) *Selected Poems of Ranier Maria Rilke*. Robert Bly, transl. New York: Harper & Row.

Rumi, J. (1981) *Open Secret*. Coleman Barks and John Moynes, transl. Putney, VT: Threshold Books.

Whyte, D. (1990) *Where Many Rivers Meet*. Langley, WA: Many Rivers Press.

Whyte, D. (1997) *The House of Belonging*. Langley, WA: Many Rivers Press.

Themes for exploration

Cohen, G. (2000) *The Creative Age, Awakening Human Potential in the Second Half of Life*. New York: Avon Books.

LeShan, L. (1994) *Cancer as a Turning Point*. New York: Plume/Putnam.

Muller, W. (1996) *How, Then, Shall We Live?* New York: Bantam Books.

Nepo, M. (2000) *The Book of Awakening*. New York: Conari Press.

Remen, R.N. (1994) *Kitchen Table Wisdom*. New York: Riverhead.

Remen, R.N. (2000) *My Grandfather's Blessings: Stories of Strength, Refuge, and Belonging*. New York: Penguin Putnam.

Books on imagery

Achterberg, J., Dossey, B. and Kolkmeier, L. (1994) *Rituals of Healing: Using Imagery for Health and Wellness*. New York: Bantam.

Lusk, J. (1992) *30 Scripts for Relaxation, Imagery and Inner Healing*. Vol. 1. Duluth, MN: Whole Person Associates.

Murdock, M. (1982) *Spinning Inward, Using Guided Imagery with Children.* Culver City, CA: Peace Press.

Books on the field of art and medicine

Le Navenec, C. and Bridges, L. (eds) (2005) *Creating Connections between Nursing Care and the Creative Arts Therapies.* Springfield, Ill.: Charles C. Thomas.

Malchiodi, C. (1999) *Medical Art Therapy with Adults.* London: Jessica Kingsley Publishers.

Malchiodi, C. (1999) *Medical Art Therapy with Children.* London: Jessica Kingsley Publishers.

Books on expressive arts

Knill, P., Nienhaus B. H. and Fuchs, M. (1995) *Minstrels of Soul: Intermodal Expressive Therapy.* Toronto: Palmerston Press.

McNiff, S. (1981) *The Arts and Psychotherapy.* Springfield, Illinois: Charles C. Thomas.

Robbins, A. (1986) *Expressive Therapy: A Creative Arts Approach to Depth-Oriented Treatment.* New York: Human Sciences Press.

How to books

Allen, P. (1995) *Art as a Way of Knowing.* Boston: Shambhala Publications.

American Psychiatric Association (1980) *Diagnostic and Statistical Manual of Mental Disorders,* fourth edition. Washington, D.C.: APA.

Diehn, G. (1998) *Making Books that Fly, Fold, Wrap, Hide, Pop Up, Twist and Turn.* Asheville, N. Carolina: Lark Books.

Graham-Pole, J. (2000) *Illness and the Art of Creative Self-Expression.* Oakland, CA: New Harbinger Publications.

Herbert, G., Deschner, J.W. and Glazer, R. (2006) *Artists-in-Residence, The Creative Center's Approach to Arts in Healthcare.* New York: The Creative Center.

Rollings, J. and Mahan, C. (1996) *From Artist to Artist-in Residence. Preparing Artists to Work in Pediatric Healthcare Settings.* Washington, DC: Rollings and Associates.

Rollins, J. (2004) *Arts Activities for Children at Bedside.* Washington, DC: WVSA Arts Connection.

Books to read aloud

Burnett, F.H. (1938) *The Secret Garden.* New York: HarperCollins.

Estes, C.P. (1997) *Women Who Run With The Wolves.* New York: Ballantyne Books.

Giono, J. (1995) *The Man Who Planted Trees.* White River Junction, Vermont: Chelsea Green Publishing.

Grimm, J. and Grimm, W. transl. Hunt, M. (1884). Accessed on 3 June 2007 at www.ucs.mun.ca/ ~wbarker/ fairies/grimm/.

Henry, O. (1992) *The Gift of the Magi* Accessed on 3 June 2007 at www.auburn.edu/~vestmon/Gift_of_ the_Magi.html.

McDonald, B. and Knight, H. (1957) *Mrs. Piggle-Wiggle.* New York: J.B. Lippincott.

Milne, A.A. (1994) *The Complete Tales of Winnie the Pooh*. New York: Dutton's Children's Books (a division of Penguin).

Milne, A.A. (1957) *Now We are Six*. New York: Dutton's Children's Books (a division of Penguin).

Milne, A.A. (1957) *When We were Very Young*. New York: Dutton's Children's Books (a division of Penguin).

Nash, O. (1998) *Selected Poems*. New York: Black Dog & Leventhal Publishers.

Remen, R.N. (1994) *Kitchen Table Wisdom*. New York: Riverhead Books, The Berkeley Publishing Group, Penguin Putnam.

Stevenson, R.L. (1913) *A Child's Garden of Verses and Underwoods*. Accessed on 3 June 2007 at www.bartleby.com/188/index1.

Index to activities

Activities appropriate for groups

Icebreakers

Media-based activities

Theme-based activities